IMAGES
of America

GERMAN
PITTSBURGH

IMAGES
of America

GERMAN
PITTSBURGH

Michael R. Shaughnessy

ARCADIA
PUBLISHING

Published by Arcadia Publishing
Charleston SC, Chicago IL, Portsmouth NH, San Francisco CA

Printed in the United States of America

Library of Congress Catalog Card Number: 2006931599

For all general information contact Arcadia Publishing at:
Telephone 843-853-2070
Fax 843-853-0044
E-mail sales@arcadiapublishing.com
For customer service and orders:
Toll-Free 1-888-313-2665

Visit us on the Internet at www.arcadiapublishing.com

*For Katherine Quinn Shaughnessy and Stephanie,
thanks for all the years of support.*

CONTENTS

ACKNOWLEDGMENTS

Tausend Dank to all the Pittsburghers who helped in this project! Especially John Canning, Mary Wohleber, Cristel Van Maurik, Michael Taylor, and all the members of the Teutonia Männerchor; Pastor Spittell at First Trinity Lutheran Church; Dick Ober, Martha Berg, and the Rodef Shalom Congregation of Pittsburgh; John Graf at Pittsburgh's Grand Hall; Don Heinrich Tolzmann; the Pastorius family at the Penn Brewery; my students and mentors; and to the following institutions: Washington and Jefferson College and the Kenneth M. Mason Sr. Research Fund, the Smithfield Congregational Church congregation, Fair Oaks Retirement Community, the Hebrew Union Institute, the Greater Beneficial Union, the Carnegie Library, the Pittsburgh Pirates, and the Archives Services Center and Nationality Rooms of the University of Pittsburgh.

INTRODUCTION

Pittsburgh is a city that has clearly been reborn from its heyday as one of the largest producers of steel in the world. The industrial roots of this great city are still clear to see in many of the neighborhoods, right next to the modern facades and bustling urban life. The ethnic heritage of the city is also not difficult to see, but the fact that Pittsburgh is predominantly a German city is less obvious. In the 2000 census, 330,625 people in Allegheny County self-claimed German heritage, the largest percentage (26 percent), ahead of the number two ethnic group, the Irish at 18 percent.

Perhaps it is the elusive nature of the term German that makes it less than visible. When the bulk of German-speaking immigrants came to Pittsburgh in the 19th century, there was no Germany. The German-speaking lands consisted of smaller countries, not politically unified. Immigrants rolled into Pittsburgh from the Hesse-Darmstadt, Swabian, and Rheinland areas. Additionally, the Austro-Hungarian Empire held influence over much of central Europe and many people from these areas came to Pittsburgh. The Swiss, German-speaking Jews, Liechtensteiners, Luxembourgers, and some Belgians also came as German speakers. For many of these immigrants, the only thing that bound them together was their shared language and abundance of jobs, not a political identity. For this reason, the term German was applied as it was the easiest way to identify the complex diversity of immigrants coming to the area. Perhaps also because of this complexity, these immigrants settled into the region and quickly identified themselves as Americans to throw off the political and ideological baggage of the old world. They saw the new world as a permanent home and quickly built up the city and established institutions that last until this day. The connection to the German language in Pittsburgh bound them initially, but slowly gave way to the unofficially official language of the land, English.

These German speakers left their mark on this great city of Pittsburgh. Despite often referring to it without the *H* at the end, the *Burg* (German for fortress) provided shelter for the diverse group of immigrants. They quickly established themselves and founded houses of worship, social clubs, and singing societies, and helped shape the city with the foundation of parks, markets, and financial institutions. They settled into neighborhoods like Birmingham (the South Side) and Allegheny City (the North Side). Eventually, through time and two wars with what later became Germany, the German-speaking immigrants of the city melted into the everyday fabric of society.

What remains are the institutions, people, products, and traditions that seem so common to Pittsburgh today, but have a clear history in the German-speaking immigrants of yesterday. This work highlights the contributions of these German Americans, in all their diversity. It

seeks to provide an overview of the types of activities that were common for these immigrants, documents the aspects of their daily life that have gone unnoticed, and highlights the fact that a great part of the city's history was multilingual. As Pittsburgh gains influence in the world today, it can look to its past for inspiration. While on the surface today, Pittsburgh does not strike a visitor as particularly German in nature, it only takes a little investigation, a trip to old Allegheny City, or a glass of the local brew to experience the German flavor that still is at Pittsburgh's core.

German Pittsburgh paints with broad strokes and covers many aspects of German-speaking life in the city. This work is not meant to be the definitive history of German Americans in the Pittsburgh region. It is designed to provide an overview of the types of institutions and experiences that German-speaking immigrants lived and are living today. It is my great hope that this work will generate more interest in the subject of German-speaking Pittsburgh and will prompt more detailed research in the future by historians who can take the time to focus on individual topics more carefully and to document the complete history that helped shape our Burg on the rivers.

Glück auf!

Michael R. Shaughnessy
Pittsburg(h), Pennsylvania

One

FIRST GERMAN SPEAKERS IN PITTSBURGH

In *Farewell to Pittsburg*, John Wrenshall (1761–1821) writes:

> In Crowds, the Germans too, of Swabian Race
> Whose grotesque figure, and ruddy face,
> Oft times excite involuntary smiles,
> And not less oft, the tedious way beguiles,
> Those all united, male and female too,
> Both old and young, to drag the wagon through,
> The deep sunk rut, with females in the rear,
> Thrusting with all their might, the rut to clear;
> While one with voice vociferous and strong,
> And free-used whip, to urge the beasts along;
> Succeed at length, the wish'd for spot to gain,
> And rest awhile, from anxious toil and pain.
> A lesson this, to men of useful lore,
> Who seek office, honour, wealth and power;
> Would they unite to seek the country's good,
> As honest Germans do, to drag their load.

In many places one will find poetic and artistic interpretations of immigrant groups. Particularly in local histories and literature, one can find depictions of the Pittsburgh "Germans." Often they were known for their hard work, their thrift, and their love of life (and beer).

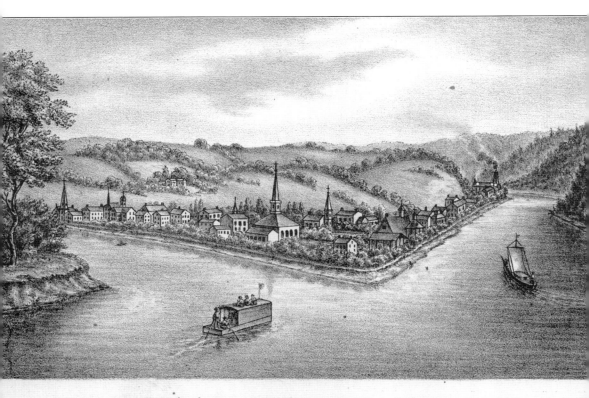

ANSICHT VON PITTSBURG IN 1817.

For many German-speaking immigrants, Pittsburgh was the edge of the American frontier. Here is an idealized etching from 1817, featuring the pastoral setting at the confluence of the Allegheny and Monongahela Rivers.

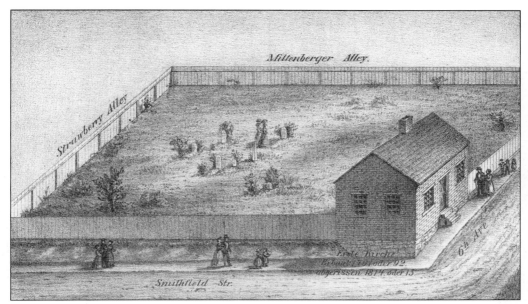

The first German-speaking church in Pittsburgh was the German Evangelical Congregationalist Church of Pittsburgh. This German-speaking congregation met in the small house pictured on the corner of Sixth Avenue and Smithfield Street. The cemetery stretched out to Strawberry and Mittenberger Alleys. This building was used from 1791 to 1814.

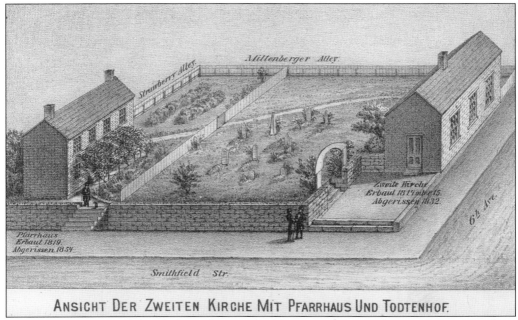

ANSICHT DER ZWEITEN KIRCHE MIT PFARRHAUS UND TODTENHOF.

The image of the second church shows the growth of the congregation with more German-speaking immigrants between 1794 and 1815. This church served the congregation until 1832. The pastor's home was constructed in 1819 and was removed in 1854. Later the growth of the city would cause them to disinter the graves in the cemetery, move it to Troy Hill, and construct a larger church on this location.

11

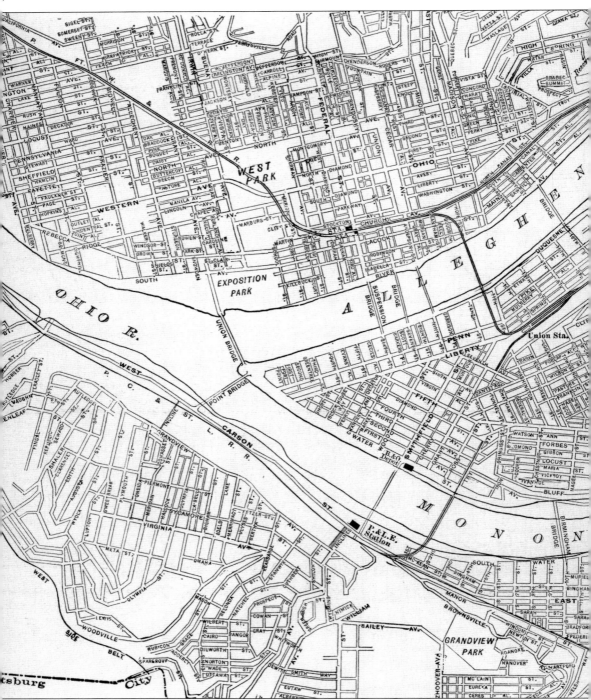

On this old map of Pittsburgh one can clearly see how the divisions of the city influenced neighborhoods and preserved language and culture. The geography, complexity of streets, hills, and rivers separated the neighborhoods. Today the highways cut through or bypass some of the former German neighborhoods on the North Side and South Side. Other German-speaking

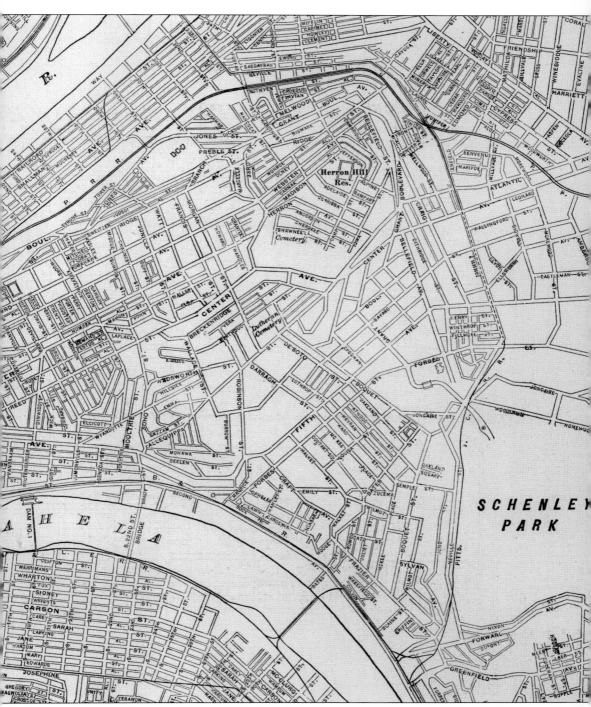

neighborhoods include Troy Hill, Mount Washington, Mount Oliver, the Hill District, East Liberty, Braddock, Etna, McKees Rocks, McKeesport, Millvale, Lawrenceville, and Manchester. This map is from 1911.

13

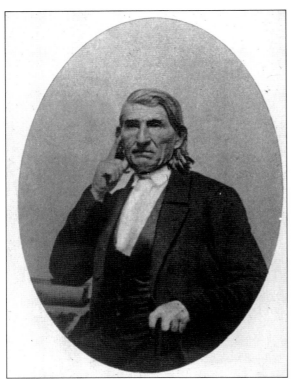

Here is Reverend F. Heyer, the first pastor of the newly formed First German Evangelical Lutheran Church of Pittsburgh in 1837. This church was the first Lutheran church in the city and was a German-speaking community.

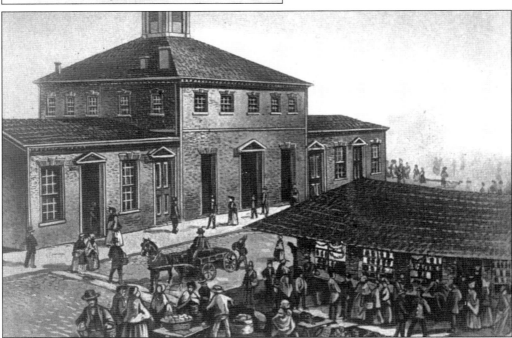

The City Courthouse of Pittsburgh was the site of where the First German Evangelical Lutheran Church met in 1837 until the completion of their first building in 1840. This congregation was the first Lutheran congregation in Pittsburgh.

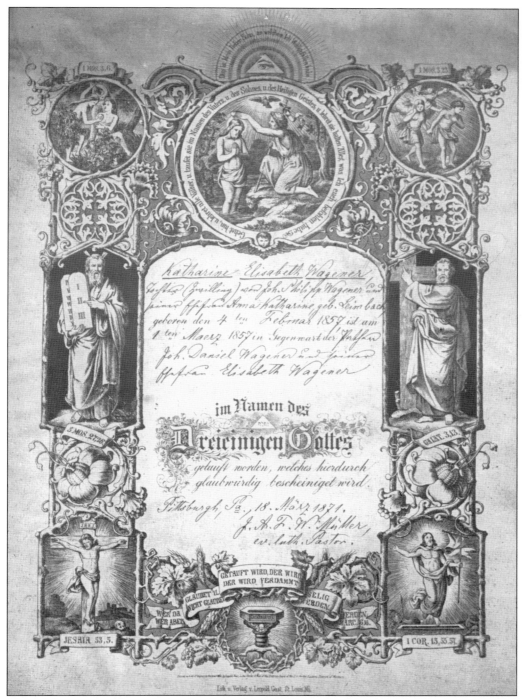

This elaborate certificate from the First German Evangelical Lutheran Church marks the baptism of Katharine Wagner on March 18, 1871. The signature is of the pastor during that period, J. A. F. W. Müller, who served from 1863 to 1871.

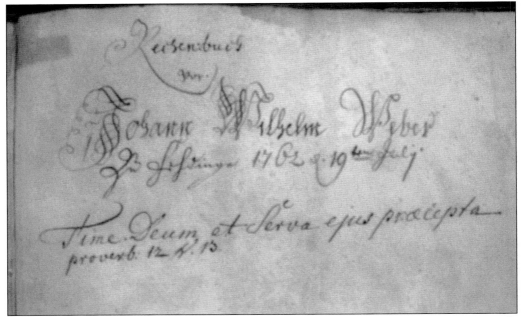

This image is from the *Reisebuch* (travel log) of Johann Wilhelm Weber, one of the early German-speaking missionaries of Pittsburgh. The log is dated 1762 and written in Latin and German. Weber arrived in Philadelphia on September 20, 1764. He first held services in Pittsburgh in a cabin on the corner of Wood Street and Diamond Alley in 1782.

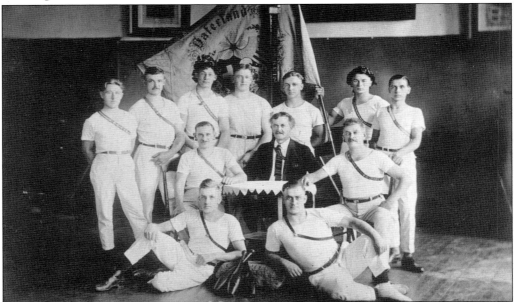

The Turner societies were founded in the United States by Friedrich Ludwig Jahn. They were primarily athletic societies but had a major political emphasis as well. In this photograph is the flag bearing the word *Vaterland*, or fatherland. In the late 19th century, progressive politics in Europe were the a part of nationalist thinking to go beyond regional control of local princes and kings toward a larger, more unified political system.

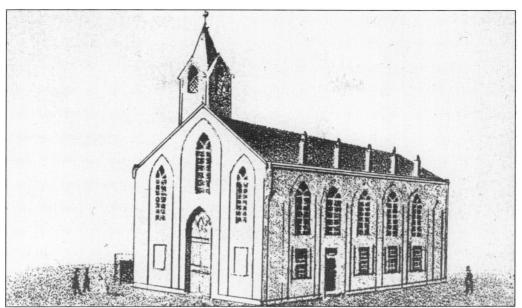

The second building of First German Evangelical Lutheran Church was located on the corner of Wylie and Sixth Streets from 1840 to 1868. It was undermined by the Pittsburgh Railroad Tunnel and replaced by the third building, which had the tallest spire in the city for the time. Typical of many successful congregations is the move from building to building throughout their history.

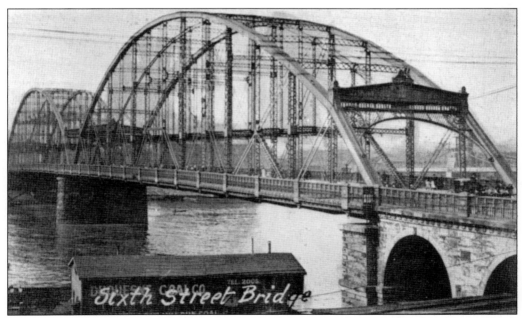

The first bridge to cross the Allegheny over to the German-speaking neighborhood was at Sixth Street. This Sixth Street Bridge served as the main connector between the German-speaking community of the North Side and the downtown area from 1892 to 1927. The bridge was replaced by one of the famous yellow "sisters" bridges, now named after the baseball great Roberto Clemente.

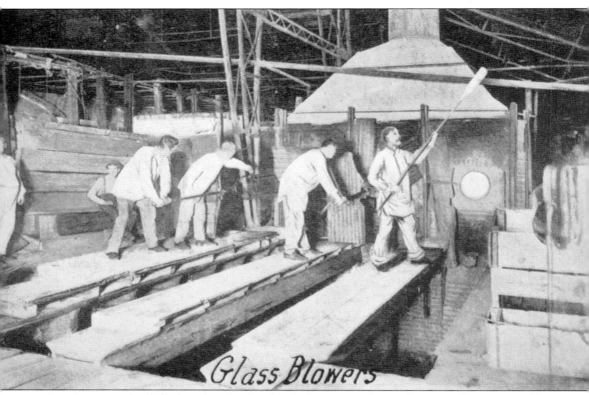

Glass Blowers

A main source for skilled workers in the glass industry was the southeastern German-speaking lands and the bohemian areas, where many emigrants came from. Such skilled glassblowers were sought by the numerous glass-producing industries in Pittsburgh. Many German immigrants and their families were former glassmakers.

Two

RELIGION

The religious holiday of *Lichtmeß* (Candlemas) on February 2 celebrates light as a precursor to spring and the Lenten holidays. The day was also used by German farmers to determine the extent of the winter by using a hedgehog in their predictions. German immigrant farmers in the Pittsburgh area adapted this custom. Instead of using a hedgehog (as in the home country) to determine the length of the winter, they used the local groundhog. In Punxsutawney, outside of Pittsburgh, the tradition has grown to international fame.

> Ist's an Lichtmeß hell und rein,
> wird ein langer Winter sein.
> Wenn es aber stürmt und schneit,
> ist der Frühling nicht mehr weit.
> (German farmer's saying)

Just as the tradition of Groundhog Day was brought over from the German-speaking lands, many other religious traditions were brought to Pittsburgh by German-speaking immigrants. Whether Catholic, Protestant, or Jewish, religion was often at the center of local life, and that meant it happened in the German language. Today the religious makeup of the city can trace many roots back to the German-speaking Pittsburghers.

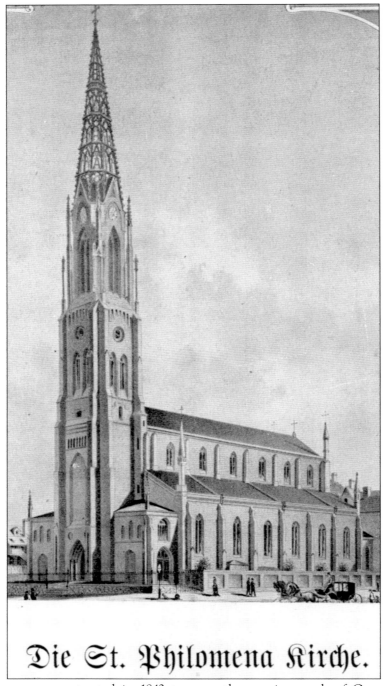

Die St. Philomena Kirche.

St. Philomena was constructed in 1842 to serve the growing needs of German-speaking Catholics in the Pittsburgh area. The location for the church used to be near Liberty Street and Fourteenth Street in the Strip District. St. Philomena is considered the mother church of the German-speaking Catholics in the area. Even as early as 1914, over 17 other German-speaking Catholic congregations were formed in the city.

St. Mary's German Church is the oldest Roman Catholic church in Allegheny City. It also holds the distinction of being one of the first German Catholic churches in the United States to convert from German to English for services. The use of German for official sermons completely ceased with the outbreak of World War I.

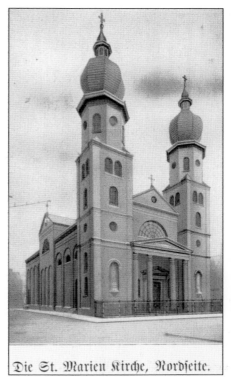

Die St. Marien Kirche, Nordseite.

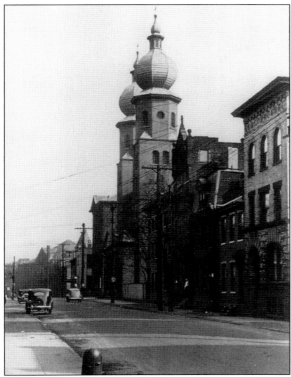

Here Old St. Mary's Church from Liberty Street can be seen, now Lockhart Street on the North Side. The church was built in Italian-style architecture, and later Austrian stained-glass windows were added in the early 20th century.

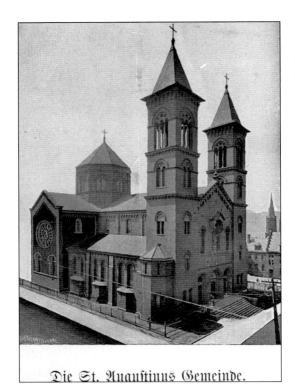

Die St. Augustinus Gemeinde.

St. Augustine Church in Lawrenceville was the third offshoot of the St. Philomena Church in the Strip District. It was constructed in 1863. It was later expanded and made a monastery and school for the Capuchin order.

St. Michael's Catholic Church, on the South Side slopes on Pious Street, was one of the larger German-speaking Catholic churches in Pittsburgh. It was founded in 1848. The growth of the German-speaking Catholic community on the South Side promoted expansion, and in 1863, this church was constructed. Other German Catholic churches in the area are offshoots of St. Michael's. Recently it was converted into condominiums for private living.

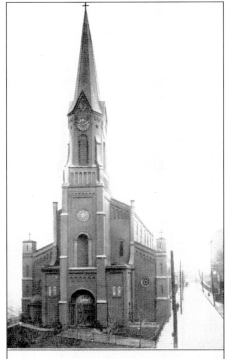

Die St. Michael's Kirche, Südseite.

The medal commemorates the fourth German Catholic Day, celebrated on September 22–25, 1890, in Pittsburgh.

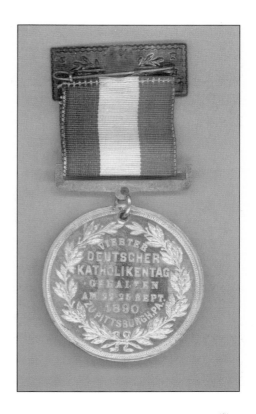

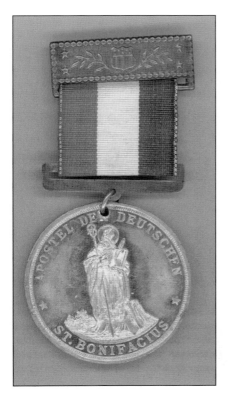

German Americans loved to show their affiliations with buttons and medals. Here is a medal from the national German Catholic Conference held in Pittsburgh. The image on the medal is of St. Boniface, the patron saint of the Germans.

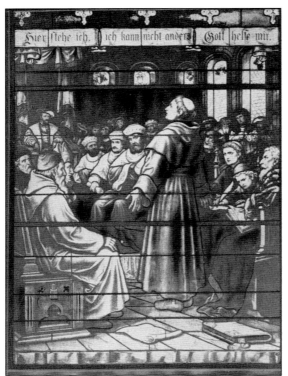

Many fine examples of stained glass are just inside the many formerly German-speaking churches in Pittsburgh. This window features Martin Luther at the Imperial Diet of Worms. The window used to be a part of the Smithfield Congregational Church. In 2006, it was still in the church but did not face out to the exterior and was in need of cleaning and restoration.

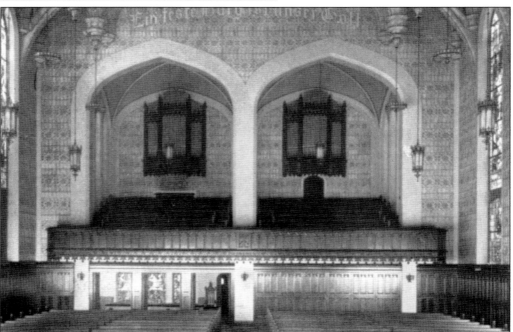

Here one can see the rear of the auditorium at the Smithfield Congregational Church in downtown Pittsburgh. Even today one can still read the German inscription: "Ein Feste Burg ist unser Gott" or "A might fortress is our God."

This is a membership certificate handed out to members who are in good standing and who were officially recognized by the church. It dates back to 1848 from the First German Evangelical Lutheran Church of Pittsburgh.

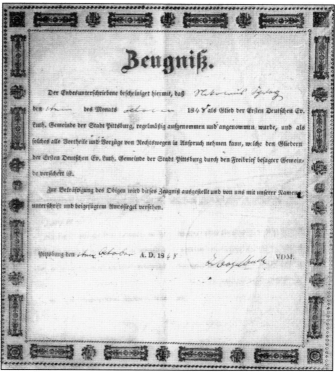

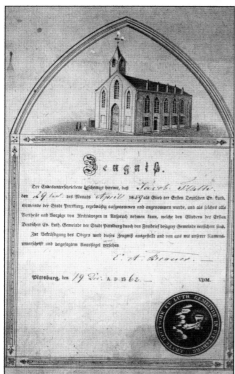

This membership certificate shows the second church building used by the First German Evangelical Lutheran Church of Pittsburgh and is dated 1862.

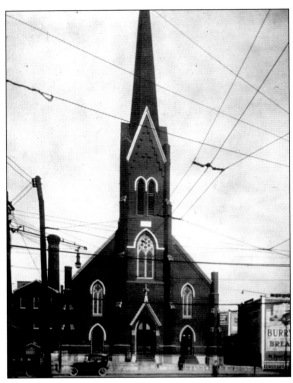

Here is the third incarnation of the First German Evangelical Lutheran Church. The church was built in 1868 after the second church was undermined. It stood until 1925 and had the highest church steeple in Pittsburgh at the time.

One can often find buttons in German from older German American Pittsburghers. This button cites the 75th-year celebration of the First German Evangelical Lutheran Church in Pittsburgh. The image here is of their third church, later taken down before the new church was constructed in Oakland.

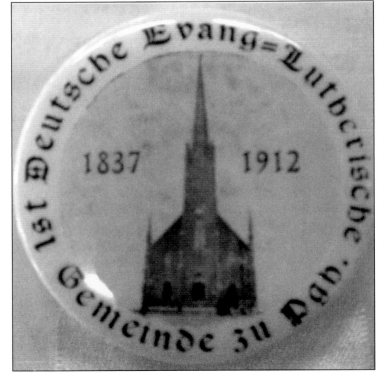

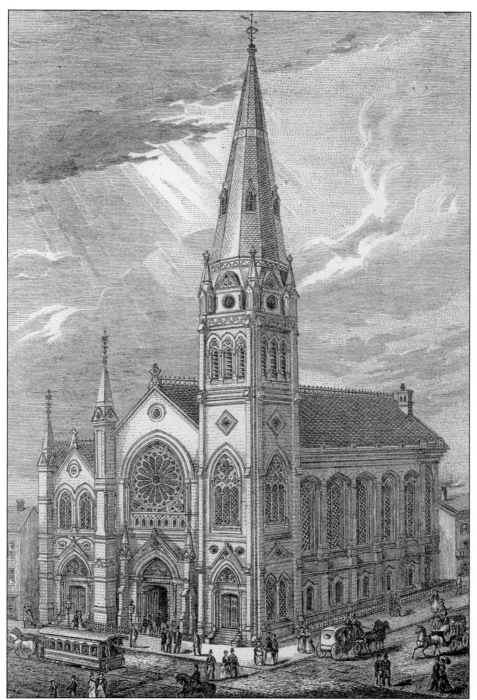

The fourth incarnation (1875–1877) of the Smithfield Congregational Church was the final version that still stands today. The structure replaced the old brick building with new stone construction. In this idealized image, the church represents the cornerstone of society and its white tower rising up toward heaven symbolizes the faith in God of its German-speaking parishioners.

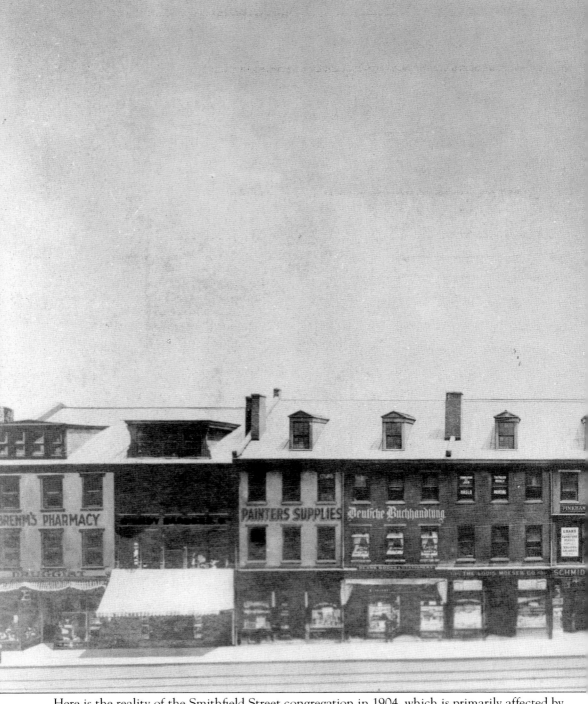

Here is the reality of the Smithfield Street congregation in 1904, which is primarily affected by the amount of air pollution in the city. This photograph shows Smithfield Street with the church on the right. Many storefronts are visible, and a *Deutsche Buchhandlung* (German bookstore)

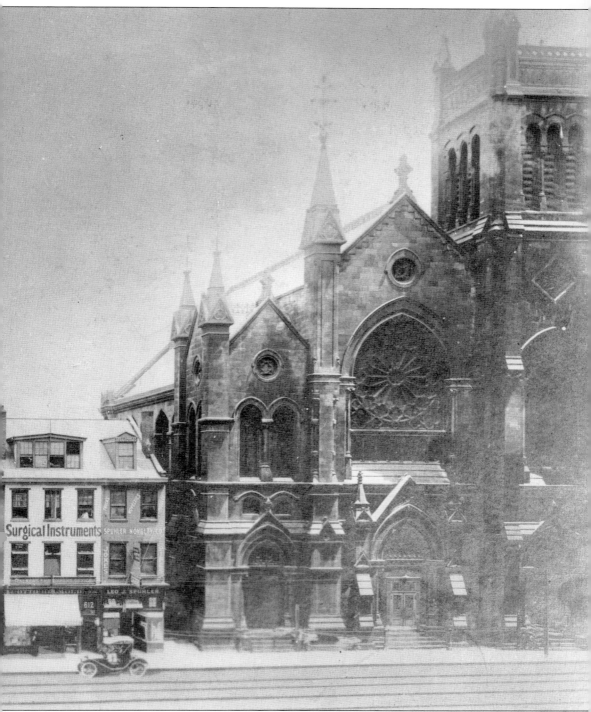

sign is visible, a sign that the area once had many German speakers living, shopping, and worshipping there.

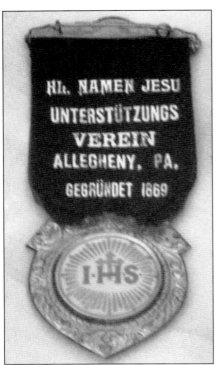

Most Holy Name Church on Troy Hill promoted the membership of its parishioners with badges and a beneficial society, similar to other churches in the area.

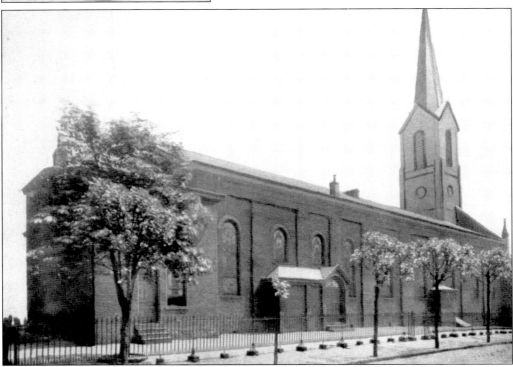

Most Holy Name Church on the North Side on Troy Hill was one of the early Catholic churches in Pittsburgh. Fr. Stephan Mollinger was the first residing priest on Troy Hill in 1868.

St. Paul's Cathedral was built in 1906 and is a centerpiece of Gothic Revival architecture in Oakland. When Oakland became a center of intellectual life with the construction of the universities, spiritual life followed as well. Some German-speaking parishioners followed, but eventually English became the language of choice for newer generations.

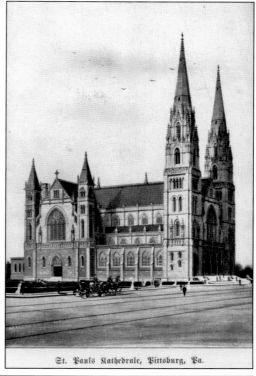

St. Pauls Kathedrale, Pittsburg, Pa.

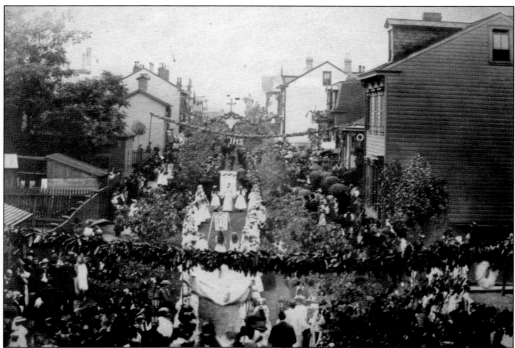

Here one can see a religious festival on the streets of Troy Hill, probably the feast of St. Anthony's. Even today, Troy Hill is a center for church-related festivals and a close-knit community.

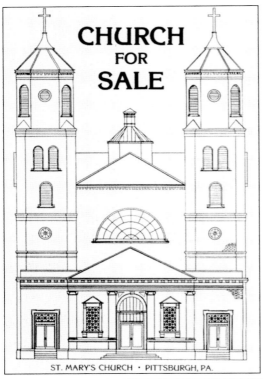

Here is an advertisement for Old St. Mary's Church on the North Side. With the movement of people to suburbs and the construction of highways, old neighborhoods gave way to new trends. Even the once-powerful churches of the city were shut down and put up for sale. Fortunately for Pittsburgh, the church became a banquet hall and city hotel, now the Grand Hall of Pittsburgh.

This prayer book in German was found in a German-speaking Roman Catholic home in Pittsburgh and dates back to the 1890s. Many Pittsburghers report finding German books in their houses. More often than not, they did not come from the old country, but were printed, purchased, and read by people in the United States.

32

St. Peter and Paul's Cathedral was founded in 1856 in East Liberty. It housed a school for 70 German-speaking children. As early as 1872, it converted to the use of English in the congregation.

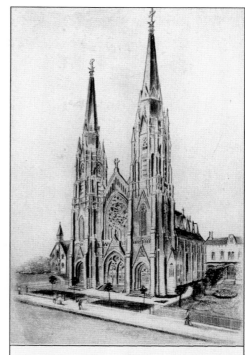

Die St. Peter und Paul's Kirche.

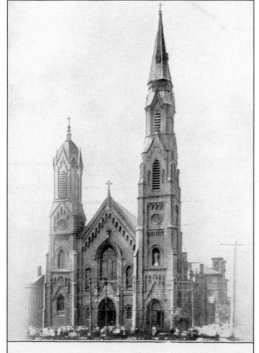

Die St. Joseph's Gemeinde, Bloomfield.

St. Joseph's in Bloomfield contained a number of additions for German-speaking parishioners, including a gymnasium, a billiards room in the basement, and a bowling alley—all aspects and activities enjoyed by the German-speaking community.

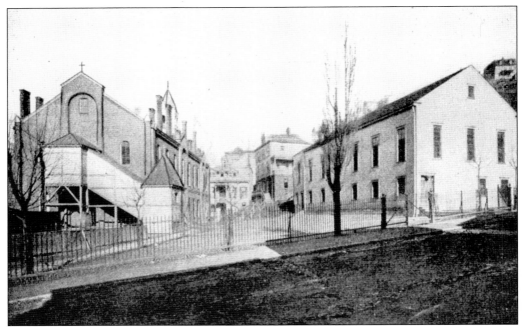

St. Boniface Church on the North Side was founded in 1884 and was expanded in 1888 due to the number of parishioners. St. Boniface is the patron saint of the Germans, so the church was aptly named.

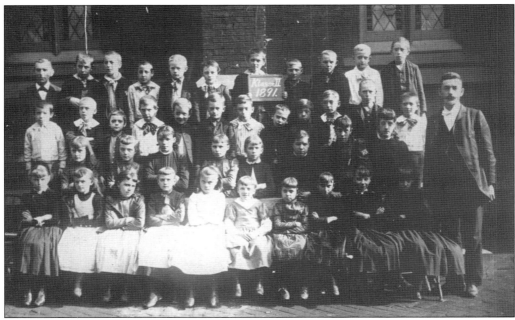

Here is the second-grade class from the German school of the First German Evangelical Lutheran Church, now First Trinity Evangelical Lutheran in Oakland. Faith-specific and German-language educations were important aspects of German-speaking religious communities in Pittsburgh.

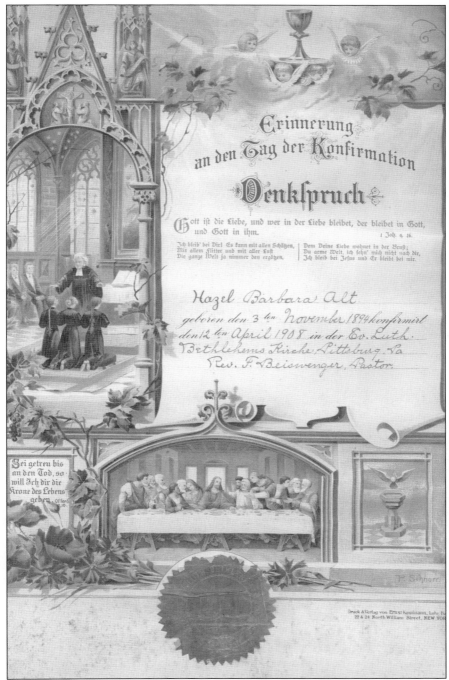

In many German-speaking churches in the United States, confirmation was conducted primarily in the German language. To mark this occasion, elaborate certificates were created and given to the confirmed youth. This certificate came from the German Bethlehem Lutheran Church on Excelsior Street in Mount Oliver. The seal of the church is placed at the bottom and is dated April 12, 1908.

Last Day in the Old Building.

The Rodef Shalom congregation of Pittsburgh first met in Allegheny City on the North Side. It chartered its organization in 1856 and moved from the North Side. Its charter states, "Impressed with the existing necessity for the formation of a German religious society, the undersigned have resolved such an association in Pittsburgh State of Pennsylvania, which is to be known by the name of Rodef Scholem." This structure was completed in 1862.

After the original Rodef Shalom temple was taken down in 1900, this new structure was erected in 1901. It contained an area for religious school, and due to the increasing numbers of the congregation, had to be torn down and expanded in 1904.

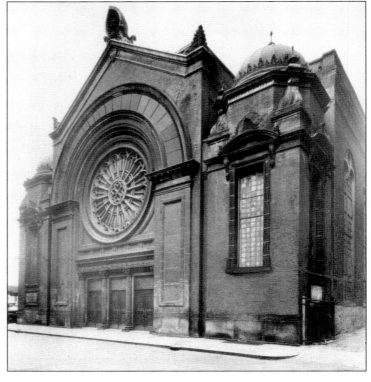

Dr. Louis Naumberg was born in 1813 in Treuchlingen, Germany. He came to Pittsburgh in 1865 to head the Rodef Shalom congregation from Philadelphia and led it until 1870. Dr. Naumberg spoke German during services. In 1870, his successor, Rabbi Lippman Mayer, spoke English in services but "felt more comfortable in German."

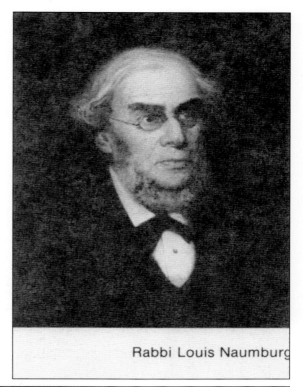

Rabbi Louis Naumburg

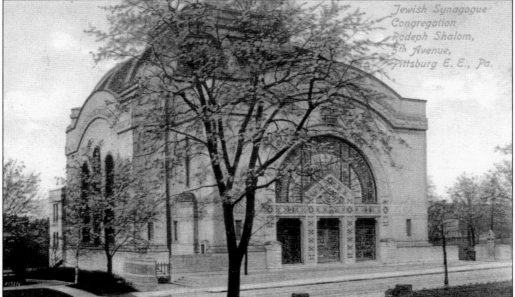

Jewish Synagogue Congregation Rodeph Shalom, 5th Avenue, Pittsburg E. E., Pa.

The newest home to the Rodef Shalom congregation is the building on Fifth Avenue. Finished in 1907, this building included architectural features of the previous structure from 1901. This building was the site of William Howard Taft's 1909 visit. President Taft was the first sitting president to address a Jewish congregation inside its house of worship during regular Sabbath services.

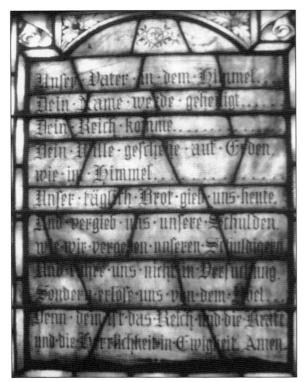

This stained-glass window inside the Smithfield Congregational Church is the Lord's Prayer in German. Due to the diverse political and geographic background of immigrants from German-speaking Europe, the use of language became the connecting factor for many in the communities and in religious services and schools.

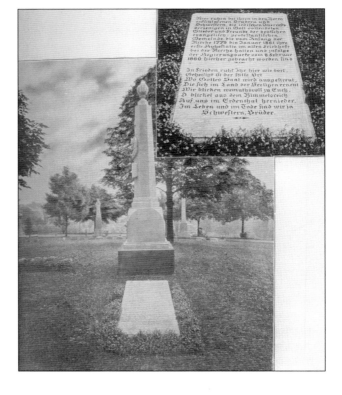

In many of the formerly German cemeteries in the Pittsburgh region, one will find memorials with German inscriptions. This memorial commemorates the life of Pastor Walter from the Smithfield Congregational Church. The cemetery is on Forbes Avenue.

The third incarnation of the Smithfield Congregational Church marks yet another growth spurt. Built in 1833, this multistory building was an impressive structure on Smithfield Street. It lasted 42 years until yet another growth prompted new construction in 1875. The Smithfield congregation notes that the official nature of the evangelical protestant churches in Germany did not occur until 1817, thus making the Smithfield congregation the oldest *official* German Evangelical Protestant church in the world.

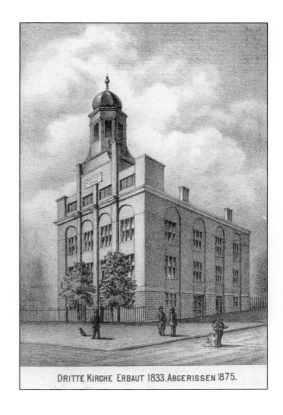

DRITTE KIRCHE ERBAUT 1833. ABGERISSEN 1875.

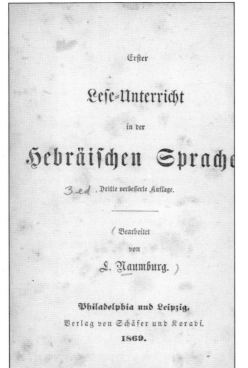

In many of the German neighborhoods, schools were formed by religious communities to teach in the German language, and from a particular religious perspective. The Hebrew school associated with the Rodef Shalom congregation in Oakland used this textbook from 1866, written by Naumberg. Note that the title and main text are written in German, despite being written for an American audience.

wenn du sißest	in deinem Hause	und wenn du gehest
בְּשִׁבְתְּךָ	בְּבֵיתֶךָ	וּבְלֶכְתְּךָ
when thou sittest	in thy house	and when thou walkest

auf dem Wege	und wenn du dich niederlegst	und wenn du aufstehest
בַּדֶּרֶךְ	וּבְשָׁכְבְּךָ	וּבְקוּמֶךָ
upon the way	and when thou layest down	and when thou risest up

und binde sie	als Zeichen	auf	deine Hand	und sie sollen sein
וּקְשַׁרְתָּם	לְאוֹת	עַל -	יָדֶךָ	וְהָיוּ
and bind them	as a sign	upon	thy hand	and they shall be

als Stirnbinde	zwischen	deinen Augen	und schreibe sie
לְטֹטָפֹת	בֵּין	עֵינֶיךָ	וּכְתַבְתָּם
as frontlets	between	thine eyes	and thou shalt write them

auf	die Pfosten	deines Hauses	und auf deine Thore
עַל -	מְזוּזוֹת	בֵּיתֶךָ	וּבִשְׁעָרֶיךָ :
upon	the door-posts	of thy house	and upon thy gates

wenn du gegessen	und satt bist	so sollst du loben
וְאָכַלְתָּ	וְשָׂבָעְתָּ	וּבֵרַכְתָּ
when thou hast eaten	and thou art satisfied	and thou shalt bless

den	Ewigen	deinen Gott	für	das Land	das Gute
אֶת -	יְהֹוָה	אֱלֹהֶיךָ	עַל -	הָאָרֶץ	הַטּוֹבָה
the	Lord	thy God	for	the land	the good

welches	Er gegeben	dir
אֲשֶׁר	נָתַן	לָךְ :
which	he gave	thee

(ist)

: ־

(is

imme

וָעֶד :

for even

Herze

לְבָבֶךָ

thy hea

ich

אָנֹכִי

I

und du f

and tho

* Eine
die einzeln

40

Leſeübungen

...erſetzung in Deutſcher und Engliſcher Sprache: *

der Ewige	unſer Gott	der Ewige	Iſrael	Höre
יְהֹוָה	אֱלֹהֵינוּ	יְהֹוָה	יִשְׂרָאֵל	שְׁמַע
...e Eternal	our God	the Eternal	Israel	Hear

ſeines Reiches	der Herrlichkeit	der Name	Gelobt (ſei)
מַלְכוּתוֹ	כְּבוֹד	שֵׁם	בָּרוּךְ
of his kingdom	of the glory	the name	blessed be

...ganzem	deinen Gott	den Ewigen	Du ſollſt lieben
בְּכָל	אֱלֹהֶיךָ	אֵת ־יְהֹוָה	וְאָהַבְתָּ
...ith all	thy God	the Eternal	thou shalt love

...ermögen	und mit ganzem	Seele	und mit ganzer
מְאֹדֶ...	וּבְכָל	נַפְשְׁךָ	וּבְכָל
...w might	and with all	thy soul	and with all

...welche	dieſe	die Worte	und es ſollen ſein
אֲשֶׁ...	הָאֵלֶה	הַדְּבָרִים	וְהָיוּ
...hich	these	the words	and they shall be

...ſchärfen	deinem Herzen	auf	heute	dir befehle
וְשִׁנַּנְתָּ...	לְבָבֶךָ	עַל־	הַיּוֹם	מְצַוְּךָ
...ach them	thy heart	upon	this day	command thee

davon	und du ſollſt reden	deinen Kindern
בָּם	וְדִבַּרְתָּ	לְבָנֶיךָ
of them	and thou shalt speak	to thy children

...iſche Ueberſetzung kann nur eine wörtliche ſein. Der Lehrer hat, wenn
...gelernt ſind, den Zuſammenhang (construction) herzuſtellen.

Here is a sample from Naumberg's text, featuring German as the source language. The first language for instruction is German, followed by Hebrew, then English as the final point of reference. The text for analysis is the Old Testament. Like Reformed Christian churches and Catholic churches, the use of German was a common feature that tied together people of faith. Since many parishioners attended religious schools and the sermons were in German, it was logical that the language of instruction would be German in these schools.

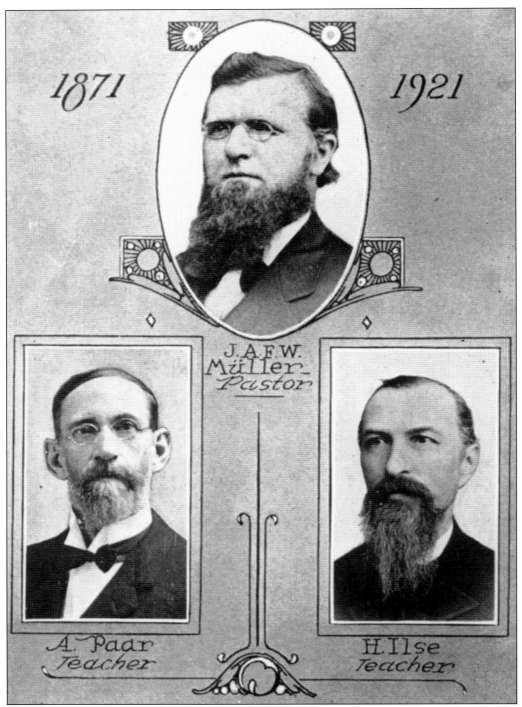

1871 1921

J.A.F.W.
Müller
Pastor

A. Paar
Teacher

H. Ilse
Teacher

Here is a commemorative image from the First German Evangelical Lutheran Church. The pastor is J. A. F. W. Müller, and below him are two teachers in the German-language school.

Despite being a German church, English was used on occasion as in this cradle roll registration sheet, generally used for Sunday school admittance.

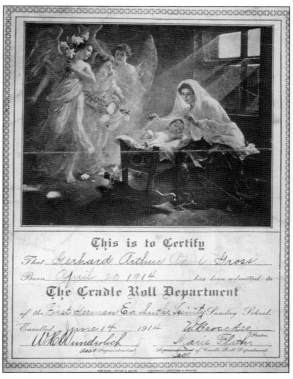

REV. E. A. BRAUER

Pastor Brauer of the First German Evangelical Lutheran Church served the congregation from 1857 to 1863.

Rev. W. Broecker was the pastor of the First Trinity Lutheran Church when the newest building was constructed. He served as the chair of the building committee.

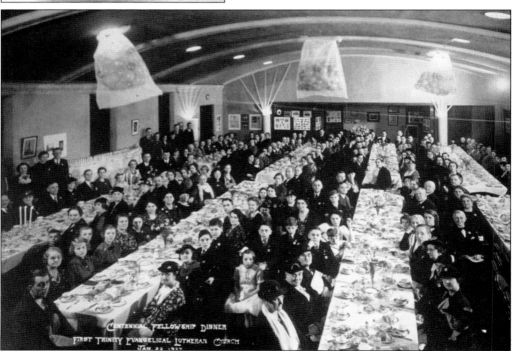

Such pictures are quite common from large German organizations in the Pittsburgh area. Here a celebration from the First German Evangelical Lutheran Church's centenary celebration in 1937 can be seen. The church they now are in is the fourth church building of their congregation, completed in 1927.

The groundbreaking for the First German Evangelical Lutheran Church can be seen here for its 1927–1928 construction of the church on Neville Street in Oakland.

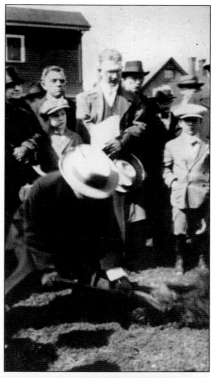

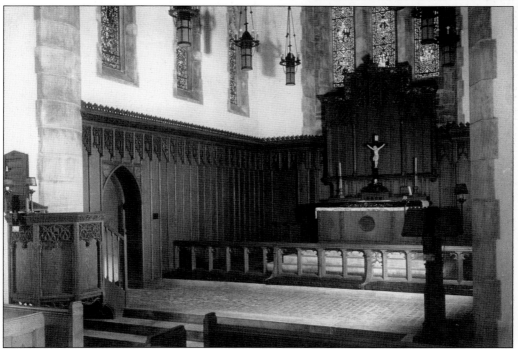

Here is the interior of the newly constructed First Trinity Lutheran Church of Pittsburgh on Neville Street.

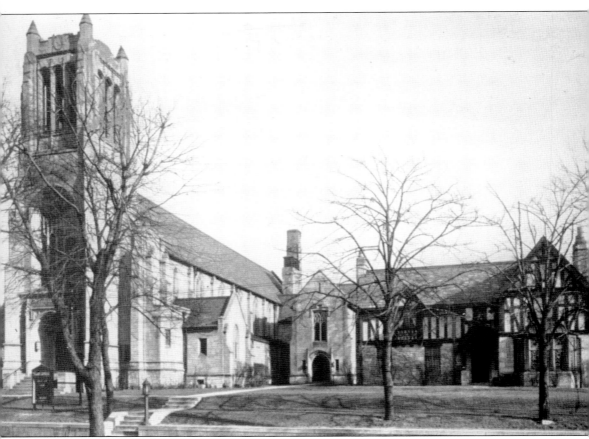

The First Trinity Lutheran Church of Pittsburgh appears shortly after its construction 1928. The new structure is the fourth incarnation of the former First German Evangelical Lutheran Church of Pittsburgh, the first Lutheran congregation in the city. Its newest home in Oakland on Neville Street features a stone church and a half-timber frame house.

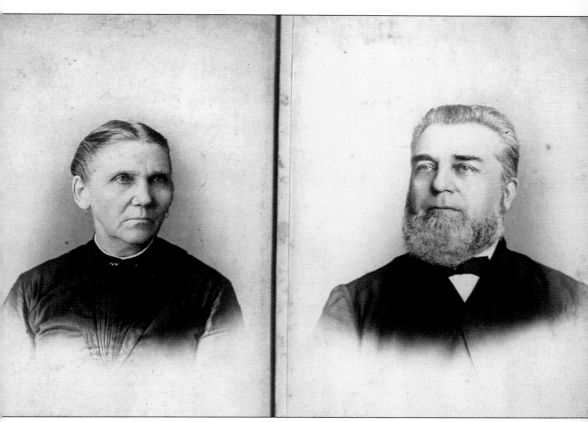

Photographic records from Protestant churches often contain images of the pastors. Here is a photograph of Pastor Ahner and his wife of the First German Evangelical Lutheran Church. Ahner served as pastor from 1880 until 1895.

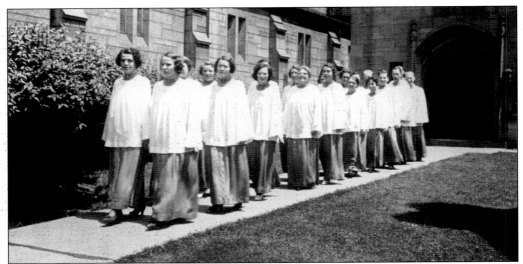

The choir of the First Trinity Lutheran Church marches down toward its entrance shortly after the new construction of the building in 1928.

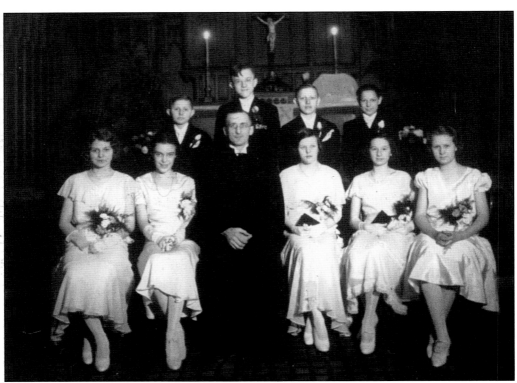

This confirmation class from the First Trinity Lutheran Church, formerly the First German Evangelical Lutheran Church of Pittsburgh, shows the newly confirmed members of their parish. Originally the confirmations would have been done in German with a memorization of the Catechism.

Three

Merchants and Money

"Hereafter the official papers of the city of Pittsburgh shall consist of three, one of which may be in the German language, in which said papers shall be published all ordinances, viewers' reports, proposals for public works and supplies." This quote was printed as a Pittsburgh city ordinance on January 9, 1888.

German-speaking immigrants started off in Pittsburgh humbly and quickly grew to prominence. The number of German-speaking banks, newspapers, and merchants who catered to this large and successful ethnic group attests to the influence they had. These merchants left a long legacy that can still be seen today through philanthropy, industry, and local traditions.

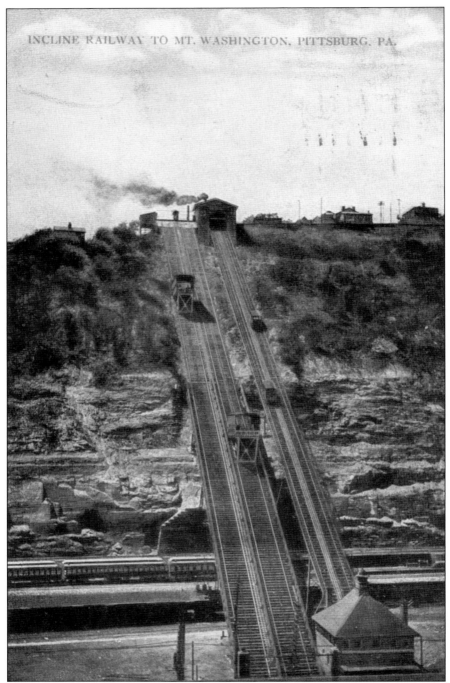

The inclines around Pittsburgh were the inspiration of both an individual and the community. Faced with a daily climb up to Mount Washington, Swiss and Austrian immigrants sought a better way. It was the German/Swiss-educated engineer Samuel Diescher who designed the Duquesne inclines. He was also a resident of Mount Washington, and the residents today still enjoy the use of these modes of transportation.

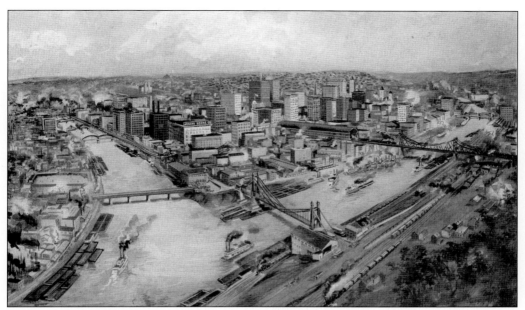

Pittsburgh quickly became a major metropolis and was known for its industries and banking sectors. The German-speaking immigrants founded many different financial institutions to cater to the greater earnings of the community and serve the financial needs of the German-speaking community. In this rendering of the city, one can see the depiction of a modern, industrial city.

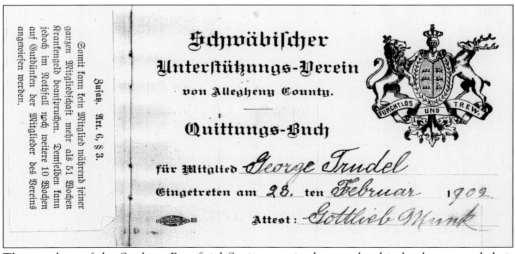

The members of the Swabian Beneficial Society received a membership book to record their transactions. The logo of the society pronounces modern American ideals combined with German concepts. Here the motto of the society is *Furchtlos und Treu*, Fearless and Loyal. The society was based on Chestnut Street in Allegheny City (North Side).

German Beneficial Union

AN UP-TO-DATE
AMERICAN SAVINGS INSTITUTION

Pays Sick, Accident and Death Benefits

MORE THAN $6,000,000.00
Distributed Among Our Needy Members

ASSETS, DECEMBER 31, 1922
$3,000,000.00

HOME OFFICE:
NOS. 1505-1507 CARSON STREET
Pittsburgh, Pa.

The handout would have been distributed among the German- and English-speaking immigrants of the city. The German Beneficial Union (GBU) later dropped the German from its name to become the Greater Beneficial Union.

This GBU pamphlet features text for both German and English speakers. Between 1900 and 1914, many parts of the city were truly bilingual and pamphlets and sometimes books were printed in both languages. Interestingly enough, the texts are not identical in meaning. Perhaps the GBU targeted their efforts culturally as well, catering more toward English and German mentalities.

Fraternity

IS THE KEYSTONE OF THE GRAND ARCH OF MODERN PROGRESS AND CIVILIZATION.

After reading this Pamphlet thoroughly you are respectfully requested to join our Union. If you are well-to-do, your name will be a support to the Union. If you are not well-to-do the Union will be a support to you.

„Spare in der Zeit, so hast Du in der Not.”

Nachdem Sie den Inhalt dieses Büchleins genau gelesen, entschließen Sie sich, dem Bunde als Mitglied beizutreten. Sind Sie reich oder wohlhabend, so bildet Ihr Name eine Stütze für den Bund; sind Sie arm, so bildet der Bund eine Stütze für Sie.

5

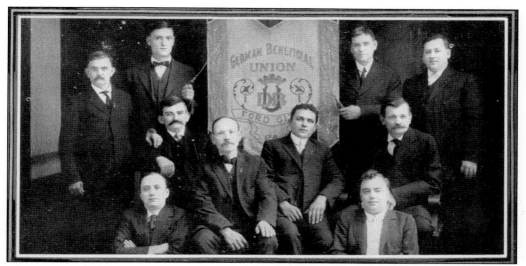

The GBU was the most notable of the German-speaking beneficial societies in Pittsburgh. Typical of many photographs from the area, a group of people, often men, stand before the banner of the society.

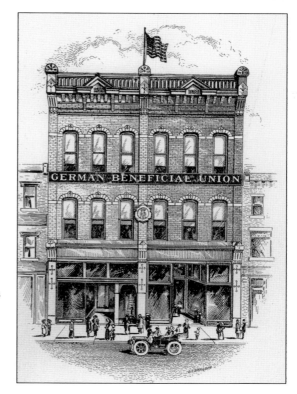

The GBU was so prosperous that it moved from its original building on the corner of Sixth and Cherry Streets downtown to a new building on Carson Street. Although targeted originally to German American citizens of Pittsburgh, the GBU was not like other organizations that allowed only German men to join. They did not discriminate on grounds of ethnic identity or sex. The building at 1505 Carson Street still stands today, although the current GBU offices have moved to 4254 Clairton Boulevard.

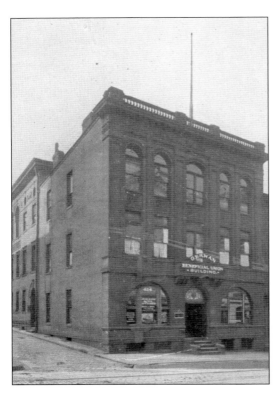

Here was the first GBU office at the corner of Sixth and Cherry Streets from 1899 to 1909. The GBU, today the Greater Beneficial Union, was a mutual benefit society initially targeted toward the German American community of Pittsburgh.

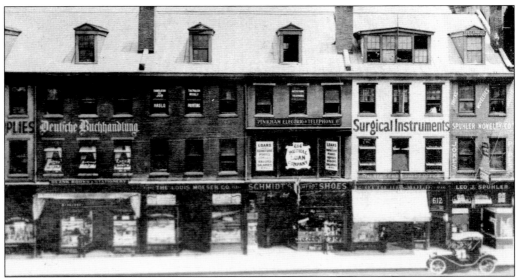

Smithfield Street in downtown Pittsburgh was a center for German American commerce and religion. Often storefronts would highlight the fact that they cater to German-speaking customers. Here is a *Deutsche Buchhandlung* or a German-language bookstore from 1904.

Before World War I, the word German was a positive attribute to add to banking and insurance institutions. Here the Germania Savings Bank lists not only its assets, but the board of directors, prominent German Americans found on numerous boards at the time.

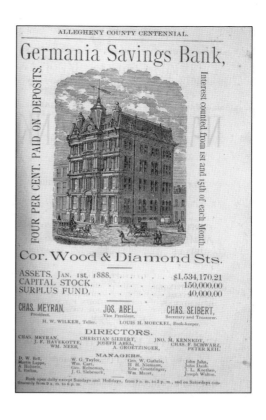

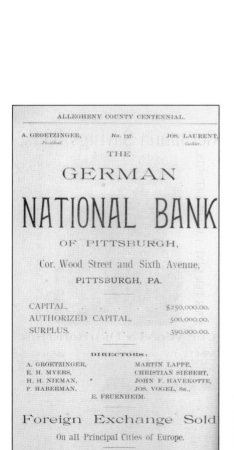

The German National Bank also lists its assets, but the board of directors is similar compared to the Germania Savings Bank. If one looks through the list of board of directors or membership rolls of the area clubs, societies, and lodges that were German speaking, one often finds the same names.

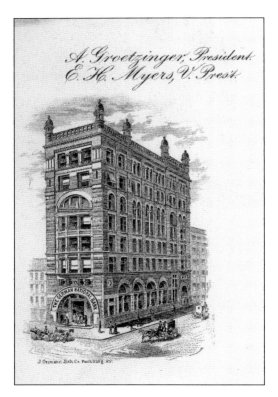

A. Groetzinger, President.
E. H. Myers, V. Prest.

J. Ottmann. Lith. Co. Puck Bldg. N.Y.

Here is a part of the bill head for the German National Bank at Sixth and Wood Streets in downtown Pittsburgh. Originally conceived to serve the needs of the German-speaking residents of the city, such financial institutions often outgrew the confines of the German-speaking community. The bank was closed in 1918 and renamed the National Bank of America.

No. 2. Allegheny, Pa. Januar 18ᵗᵉ 1903.

Erhalten von *Paul Langbein* Finanz-Sekretär des

Schwäbischen Unterstützungs-Vereins von Allegheny County,

Siebenzehn Dollars 50 Cents.

$17 50/100 *William Roll* Schatzmeister.

The Swabian Beneficial Society of Chestnut Street on the North Side was one of the financial societies providing job security insurance and savings programs. Here is a payment voucher for the society.

Vereins-Notizen | **Vereins-Notizen**

THE GERMANS TO THE FRONT!
BUNTER ABEND
zu Gunsten des Fonds für das
DEUTSCHE ZIMMER
abgehalten von den Delegierten des D. A. Z. W., in der Halle des Vereins
Deutscher Kameradschaft, am Samstag, den 22. November 1930.
Deutsche, merkt Euch das Datum! Behaltet diesen Abend frei.

10-11

This small advertisement placed in the newspaper encourages Germans to step forward and contribute to a fun-filled evening that will help raise money for the new nationality rooms at the Cathedral of Learning at the University of Pittsburgh.

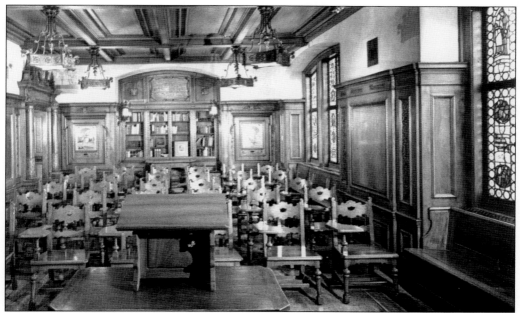

Once the Germans established themselves, they could donate money to promote their culture. The nationality rooms were such a cause for the ethnic minorities of the city. An anecdote states that while other ethnic societies had great plans and designs for their nationality rooms, but had yet to raise the funds, the Germans had no drawings or designs for the room, but already had raised the money to build it. Here is the German Nationality Room in this photograph by H. K. Barnett.

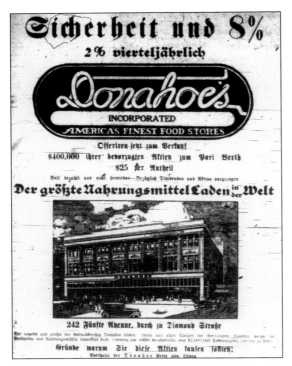

Donahoe's Grocery downtown was a Pittsburgh institution for many years. In this advertisement marketed toward the German-speaking community, it claims to be the largest grocery store in the world.

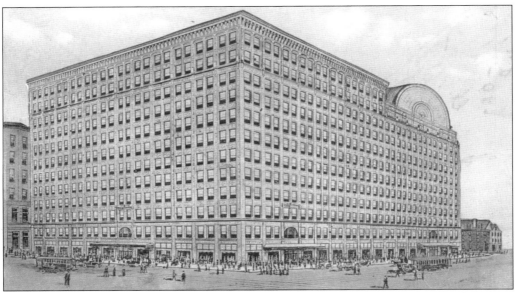

The "Big Store" for Kaufmann's was located at the corner of Smithfield Street and Fifth Avenue in downtown Pittsburgh. The Kaufmann brothers, part of a first-generation German immigrant family from the Hesse-Darmstadt region, started by selling wares on the South Side. Eventually they opened a tailor shop on Carson Street in 1867 that became a department store. Their department store chain grew and was only recently bought by Federated Department Stores. The Kaufmann family was also known for its contracting of architect Frank Lloyd Wright and the construction of the house known as Falling Waters.

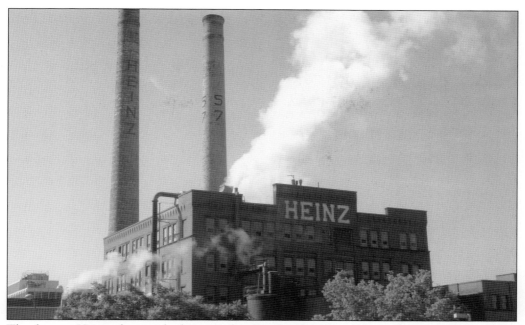

The famous Heinz plant with the neon ketchup bottle is located on the north shore of the Allegheny River, right below Troy Hill. H. J. Heinz, son of German immigrants, made his 57 varieties with the Pennsylvania Keystone logo famous the world over. This plant no longer produces ketchup, but is being converted into luxury loft apartments.

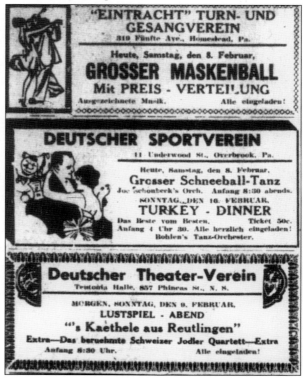

Many social events were advertised in the local German newspaper *Freiheits Freund,* or Freedom's Friend. Here is an advertisement for local events sponsored by various German-speaking organizations in Pittsburgh. The events mirror seasonal events in Germany such as a *Fasching* or Carnival celebration, and the Swiss theater production and yodeling group. As German Americans became more successful, they had more social events and private social clubs.

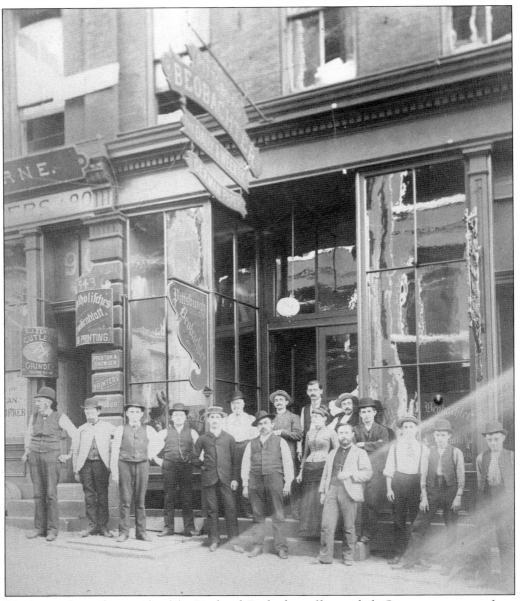

The image shows the outside of the *Pittsburgh Beobachter* offices, a daily German newspaper from 1890–1923. The address was 88 Diamond Street, formerly in Allegheny City on the North Side. The *Pittsburgh Beobachter* was a Roman Catholic newspaper of Pittsburgh. Other daily German newspapers of the city included *Der Freiheits Freund* (1859–1942), *Das Volksblatt* (1859–1942), and *Der Sonntagsbote* (1878–1942).

Originally the German-speaking neighborhoods were found on the banks of the three rivers. After many years, some of the immigrants earned enough money to move out of the traditional working-class neighborhoods. In addition, the smoke in the city was a major factor to move out to the suburbs. Here is an early advertisement for plots of land in Squirrel Hill for $200.

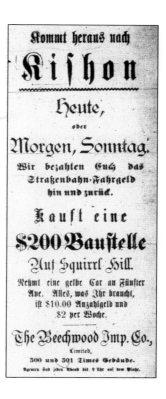

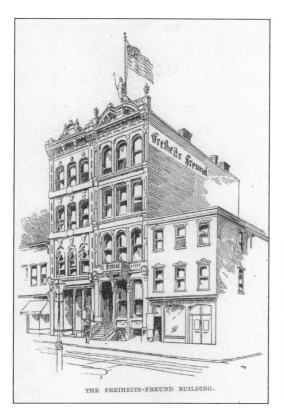

THE FREIHEITS-FREUND BUILDING.

Here is a depiction of the Freiheits Freund Building at 545 Smithfield Street. The complete record of the newspaper is available at the main branch of the Carnegie Library in Oakland. It is a great source of information about the rise and fall of the German-language community in the Pittsburgh area. Even if one cannot read German, one will recognize names and institutions of the city that once catered to the German speakers.

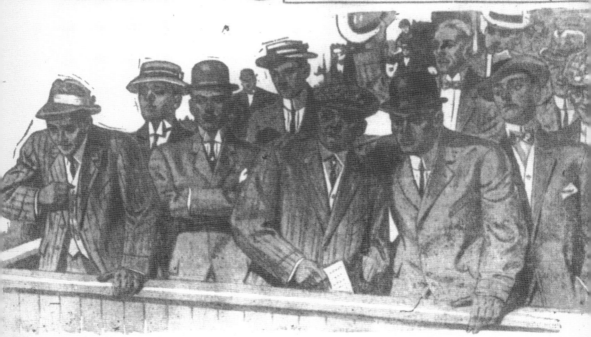

KAUFMANN'S
"THE BIG STORE"

Kleidet Euch elegant--Selbst für das Ball-Spi

Zahlt $10
Tragt einen $15 Anzug

Zahlt $15
Tragt einen $20 Anzug

Zahlt $20
Tragt einen $25 Anzug

This Kaufmann's advertisement combines the marketing of clothing to the German-speaking population and its love for baseball. The advertisement read, "Clothe yourself elegantly for the ball game." Kaufmann's offered $10, $15, and $20 suits for its customers in 1909.

Four

INDUSTRIES AND INSTITUTIONS

This is a section of Friedrich Bodenstedt's *Smoke City Pittsburg*, published in 1882, translated by the author:

> It appeared to my eyes as if a primeval fog enveloped the world, occasionally broken by flickers of light. The fog subsided only to the ever higher climbing houses, unveiling a powerful force near which hundreds of flames from black chimneys burst up to heaven. In the reflection of the waters there were just as many. The further I came, the more the flames grew in size and number and I believed I could have counted thousands of them. Black clouds grew from them and obscured the view here and there constantly creating a deluge of new images in my mind. Near to me everything was clear; in the distance everything ambiguous, only occasionally a clear perspective. In such a manner were my first impressions of Pittsburg as they remain in my memory.

Despite the overt industrialization in this description, for many Germans in the 19th century such industry meant progress and, most importantly, jobs. The industrial might of the city created wealth among many German-speaking immigrants, and this wealth in turn created long-standing institutions. This chapter seeks to not only describe the industrial aspects of German-speaking Pittsburgh, but to show how the wealth created German-speaking institutions, of which many still exist.

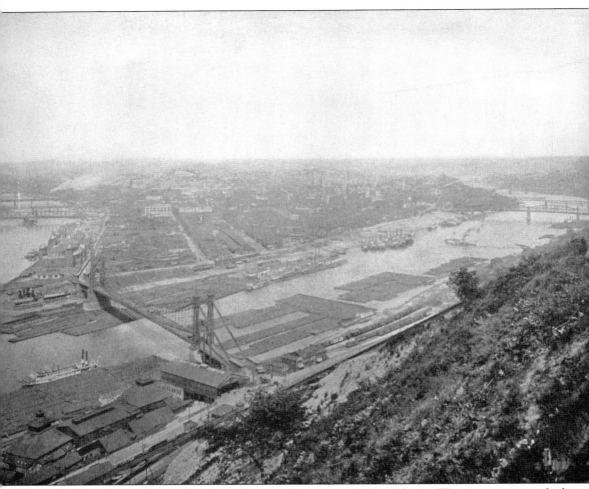

Pittsburgh was above all, and until recent history, an industrial city. The rivers were packed with shipping barges, the factories used them as dumping grounds, and the amount of pollution earned it the nicknames "Smoke City" and "Hell with the lid off." This view shows Pittsburgh in its industrial growth. During this time many German immigrants came and lived in the city on either shore of the rivers. During this time of economic growth, many of the institutions of the city grew up and many were influenced by the German-speaking community.

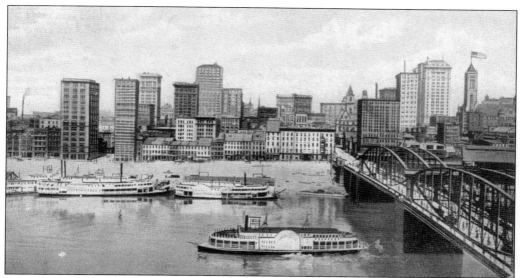

Here is the suspension bridge over the point that stood from 1877 to 1927. The bridge was inspired by the wire-cable suspension technology developed by John Roebling of Saxonburg. Roebling, a German immigrant from Muehlhausen, utilized this wire-cable technology to build the Brooklyn Bridge. Previously, he also built a suspension bridge over the Monongahela at Smithfield Street. Today the oldest bridge in Pittsburgh is there, it was built between 1881 and 1883 by Gustav Lindenthal, another German-speaking engineer and founding member of the German Engineering Society of Pittsburgh.

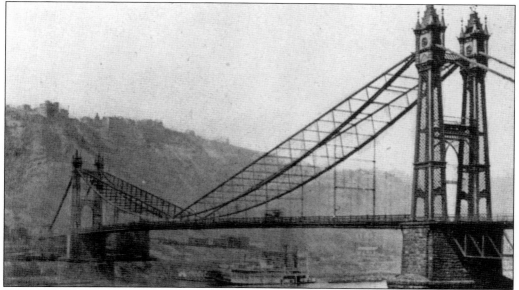

A more idealized version of the same area featured on a postcard shows the industry and traffic on the river but hides the dirty industrialization that was the reality for many years. For Germans, this industrialization led to many picnics and trips out to the suburbs for nature. One popular destination was the Linden Grove in Castle Shannon. While in other cities Germans had their beloved beer gardens, Pittsburgh was devoid of them, probably due to the amount of smoke in the air.

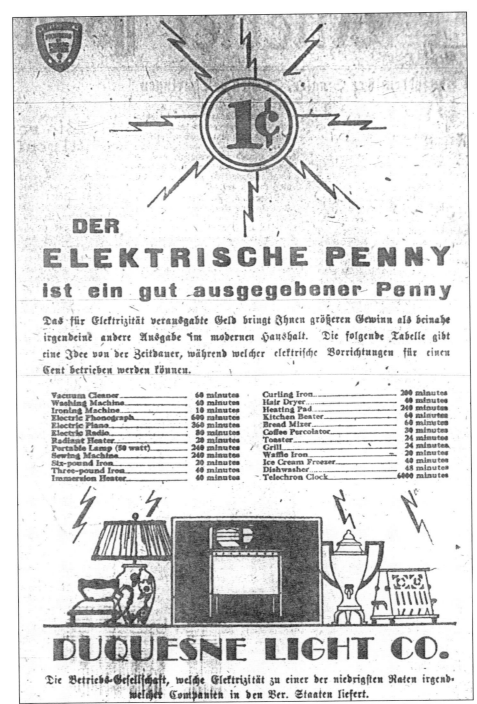

DER ELEKTRISCHE PENNY

ist ein gut ausgegebener Penny

Das für Elektrizität verausgabte Geld bringt Ihnen größeren Gewinn als beinahe irgendeine andere Ausgabe im modernen Haushalt. Die folgende Tabelle gibt eine Idee von der Zeitdauer, während welcher elektrische Vorrichtungen für einen Cent betrieben werden können.

Vacuum Cleaner	60 minutes	Curling Iron	200 minutes
Washing Machine	40 minutes	Hair Dryer	40 minutes
Ironing Machine	10 minutes	Heating Pad	240 minutes
Electric Phonograph	600 minutes	Kitchen Beater	60 minutes
Electric Piano	360 minutes	Bread Mixer	60 minutes
Electric Radio	80 minutes	Coffee Percolator	30 minutes
Radiant Heater	20 minutes	Toaster	24 minutes
Portable Lamp (50 watt)	240 minutes	Grill	24 minutes
Sewing Machine	240 minutes	Waffle Iron	20 minutes
Six-pound Iron	20 minutes	Ice Cream Freezer	40 minutes
Three-pound Iron	40 minutes	Dishwasher	48 minutes
Immersion Heater	40 minutes	Telechron Clock	6000 minutes

DUQUESNE LIGHT CO.

Die Betriebs-Gesellschaft, welche Elektrizität zu einer der niedrigsten Raten irgendwelcher Companien in den Ver. Staaten liefert.

Duquesne Light and other utilities regularly placed advertisements in the German daily newspapers. Here its marketing slogan reads, "The electric penny is a well spent penny!" In detailed fashion the advertisement describes how much use one got out of an appliance for 1¢ in 1928.

This structure on the South Side of Pittsburgh on Eighteenth Street was the former German International Order of Odd Fellows (IOOF) hall. The architecture is red brick and is typical of German construction in the United States for the late 19th century. The late 19th century was a time when the architecture of some areas took on a German feel. The IOOF was founded in Germany in 1870 and shares several symbols with other organizations of the time including the all-seeing eye and the beehive.

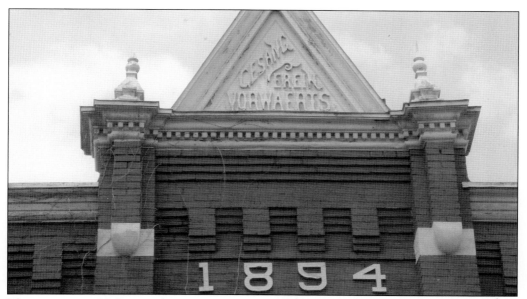

There were over 20 German-language singing societies in Pittsburgh at one time. The *Vorwaerts Gesangverein* in Lawrencville on Holmes Street is one of many defunct singing societies with a building still standing. The redbrick facade is typical of the German building style for this region.

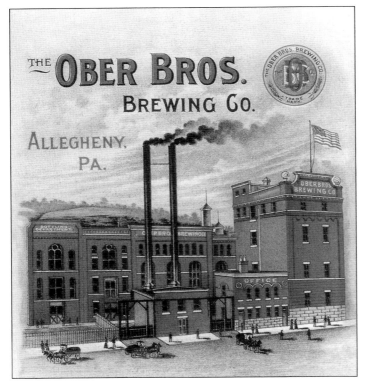

Thatsachen für das Bier-konsumirende Publikum.

[German-language advertisement text for Pittsburgh Brewing Company]

Pittsburgh Brewing Company.

Even marketing of one of Pittsburgh's favorite products—beer—takes on a cultural connotation in Pittsburgh. Here is an advertisement for all the Pittsburgh Brewing Company beers, listing the "facts" about beer consumption. This organized, fact-based list of the benefits of drinking beer appealed to the German-speaking population, and numerous such advertisements were run through the years by the Pittsburgh Brewing Company.

One of the most successful and popular breweries in the Pittsburgh area was the Eberhardt and Ober Brewing Company, or the E&O. Today the E&O brewery is the home of the Pennsylvania Brewing Company, the home of Penn Pilsner. Here is an advertisement for the Ober Brothers Brewery of Allegheny. The Ober family still lives in the area and is proud of its heritage.

Local breweries advertised not only specifically to the German immigrants due to their love of the beverage, they also targeted the social classes of their customers. Here Lutz beer's slogan reads, "Beloved by workers."

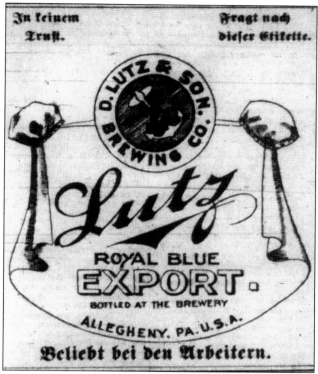

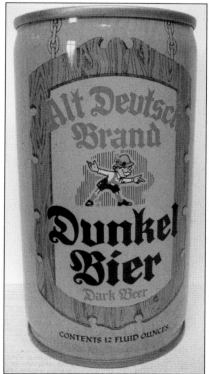

Despite not being a true "German" beer, using German in the brand name or images that conjure up Germany has always been common among brewers in the United States. Here the Pittsburgh Brewing Company featured its Alt Deutsch brand with the name Dunkel Bier, German for dark beer.

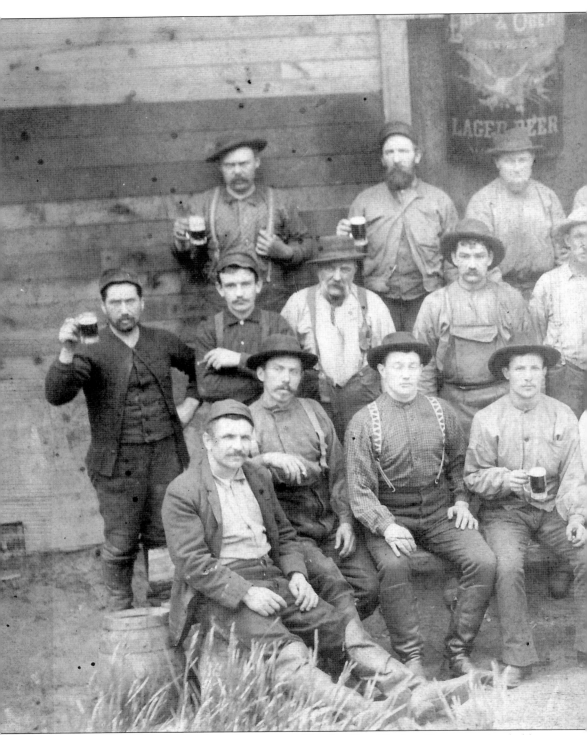

Brewery workers were often from German-speaking families. The local brewers union held many meetings in German and kept their records in German as well. Here is a group of brewery

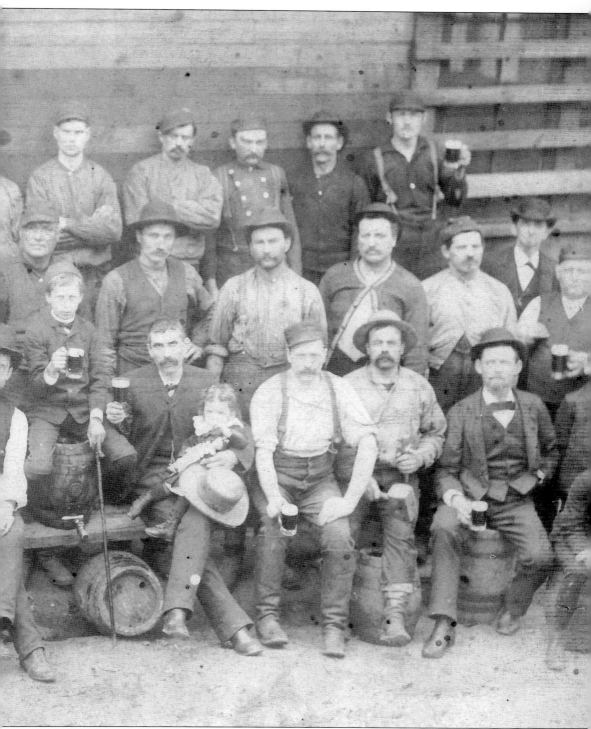

workers from the Eberhardt and Ober Brewing Company. The brewery union's meeting records are housed at the University of Pittsburgh and are primarily in German.

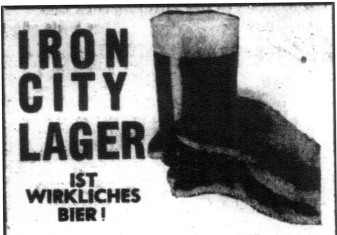

IRON CITY LAGER

IST WIRKLICHES BIER !

Wirkliches Bier kann nicht durch blosse Behauptungen gemacht werden. Dazu gehoert LANGE ERFAHRUNG. Bei weitem die aelteste Sorte Bier im westlichen Pennsylvanien und eine der aeltesten im Land ist IRON CITY. Bestehen Sie daher auf diesem Fabrikat und erlangen Sie **wirkliches Bier**! Jeder Schluck ein Hochgenuss.

Pittsburgh Brewing Co., Pittsburgh, Pa.
SChenley 7400

Iron City from the Pittsburgh Brewing Company has grown to be one of the most recognizable beer names in Pittsburgh. Here is a newspaper advertisement for the beer, appealing to its German-speaking customers. The advertisement claims, "Iron City Lager is Real Beer!"

Pittsburgh was home to over 200 different breweries through its history. Many of the small breweries in the area were eventually bought up by larger breweries. Even the larger breweries were purchased. The Keystone Brewing Company was purchased by Pittsburgh Brewing Company. Terms like "lager" and "pilsner" beer were synonymous for German-style beer.

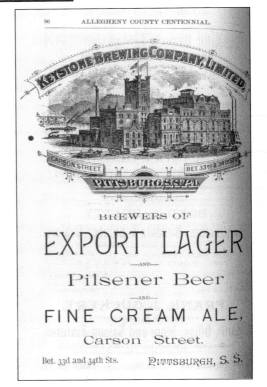

96 ALLEGHENY COUNTY CENTENNIAL.

KEYSTONE BREWING COMPANY, LIMITED.

CARSON STREET. BET. 33RD & 34 DISTS

PITTSBURGH, S.S. 721.

BREWERS OF

EXPORT LAGER
— AND —
Pilsener Beer
— AND —
FINE CREAM ALE,
Carson Street.

Bet. 33d and 34th Sts. PITTSBURGH, S. S.

Beer is a staple of the German-speaking immigrant. Commemorative mugs are common among the various German American societies in Pittsburgh. Here is a mug from the German Engineering Society, *Deutsch-Amerikanischer Technischer Verein*. This mug commemorated the engineering day celebration in 1911.

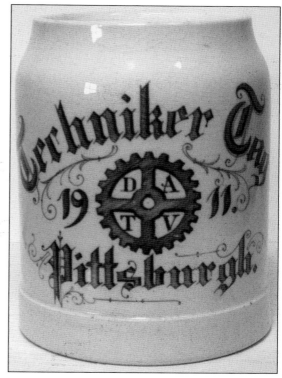

The *Deutsch-Amerikanischer Technischer Verein von Pittsburgh* (German American Engineering Society of Pittsburgh) was founded in 1887. Its founding members were well-respected engineers, including names like Diescher (inclines) and Lindenthal (Smithfield Street Bridge).

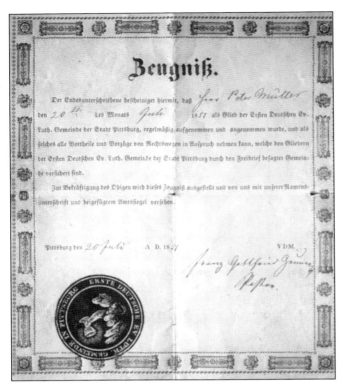

This church membership certificate dates back to 1857, 20 years after the founding of the First German Evangelical Lutheran Church of Pittsburgh in 1837. In 1837, the members met in the city courthouse before purchasing their own land and building in 1840. German Americans often created certificates to show the inherent longevity of their organizations, many of which have become Pittsburgh religious and social institutions of the city.

Local baptismal records for churches are common ways for genealogists to trace their family trees. In Pittsburgh one is likely to find these records in German. This entry shows many of the famous Pittsburgh names such as Voegtly. Other notable German Americans with entries in this church are H. J. Heinz and the Trax family.

This certificate marks the death of Johann Heinrich Demmler, the founder of the German Protestant Orphanage in West Liberty. It is signed by Friedrich Ruoff, pastor of the First German United Evangelical Protestant Church.

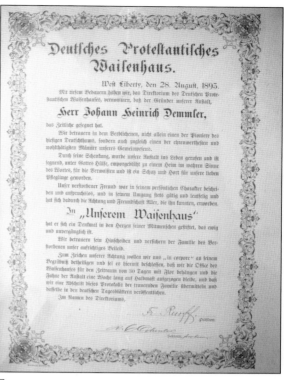

Deutsches Protestantisches Waisenhaus.

West Liberty, den 28. August, 1895.

Mit tiefem Bedauern haben wir, das Direktorium des Deutschen Protestantischen Waisenhauses, vernommen, daß der Gründer unserer Anstalt,

Herr Johann Heinrich Demmler,

das Zeitliche gesegnet hat.

Wir betrauern in dem Verblichenen, nicht allein einen der Pioniere des hiesigen Deutschthums, sondern auch zugleich einen der ehrenwerthesten und wohlthätigsten Männer unseres Gemeinwesens.

Durch seine Schenkung, wurde unsere Anstalt ins Leben gerufen und ist segnend, unter Gottes Hülfe, emporgeblüht zu einem Heim im wahren Sinne des Wortes, für die Verwaisten und ist ein Schatz und Hort für unsere lieben Pfleglinge geworden.

Unser verstorbener Freund war in seinem persönlichen Charakter bescheiden und anspruchslos, und in seinem Umgang stets gütig und leutselig und hat sich dadurch die Achtung und Freundschaft Aller, die ihn kannten, erworben.

In „Unserem Waisenhaus"

hat er sich ein Denkmal in den Herzen seiner Mitmenschen gestiftet, das ewig und unvergänglich ist.

Wir betrauern sein Hinscheiden und versichern der Familie des Verstorbenen unser aufrichtiges Beileid.

Zum Zeichen unserer Achtung wollen wir uns „in corpore" an seinem Begräbniß betheiligen und sei es hiermit beschlossen, daß wir die Office des Waisenhauses für den Zeitraum von 30 Tagen mit Flor behängen und die Fahne der Anstalt eine Woche lang auf Halbmast aufgezogen bleibe, und daß wir eine Abschrift dieses Protokolls der trauernden Familie übermitteln und dieselbe in den deutschen Tagesblättern veröffentlichen.

Im Namen des Direktoriums,

F. Ruoff, Präsident.

1 Johann Schuller Jr. 1911

Konstitution

— und —

Nebengesetze

— des —

Deutschen Protestantischen Waisenhauses

— von —

Pittsburgh, Pa.

(Gegründet 1887)

1917

The German Protestant Orphanage in West Liberty was an offshoot of the Smithfield Congregational Church. Orphans of members of the congregation were taken in and provided for. Additionally, members of the local community could apply for admittance of children should parents die or become incapacitated. Usually, well-to-do members of the congregations would donate land and money to fund a home for children, elder members, or the poor.

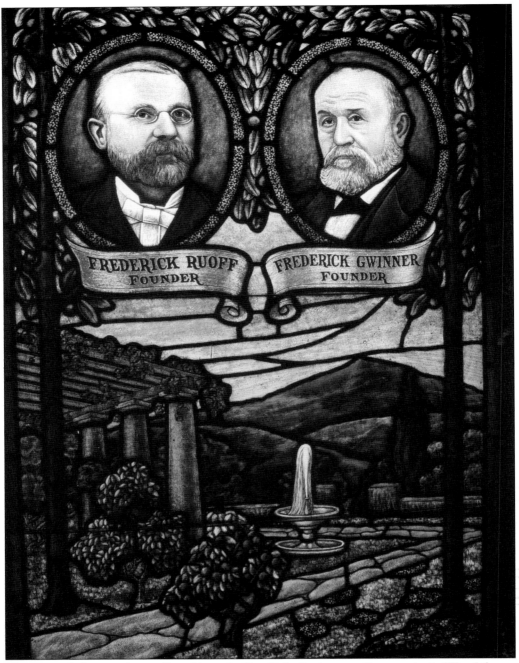

This stained-glass window, still visible at the Fair Oaks Retirement Community in West Liberty, commemorates the founders of the retirement community. Here is pastor Ruoff and cofounder Frederick Gwinner, both German American benefactors in Pittsburgh.

The original German Protestant Orphanage was founded by Friedrich Gwinner on the site of the Demmler family summer home in West Liberty. Later a home for the aged would be established near this site that still exists today.

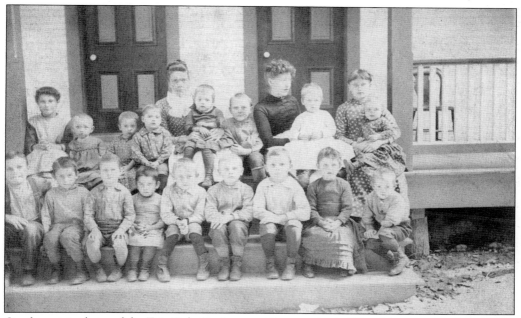

On the original site of the Fair Oaks Retirement Community in West Liberty, an orphanage for Protestant children was constructed and founded by Friedrich Gwinner in 1874. Seen here is the first group of orphans housed at the facility. The home was intended to not only serve the religious purposes of the church, but to provide a place where German-speaking children could go should their parents die or be incapable of caring for them.

Typhus and other diseases were common among orphans in the late 19th century. This quarantine house was constructed on the site of the German Protestant Orphanage in West Liberty.

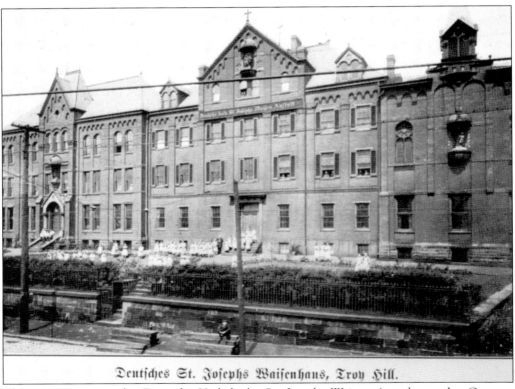

Deutsches St. Josephs Waisenhaus, Troy Hill.

This structure was the *Deutsche Katholische St. Josephs Waisen Anstalt,* or the German Catholic St. Josephs Orphan Asylum on Troy Hill. On this site today is North Catholic High School. Typical of many of religious groups in the German-speaking community, each sect of faith would later construct homes for the aged, schools, and orphanages to benefit their German-speaking members.

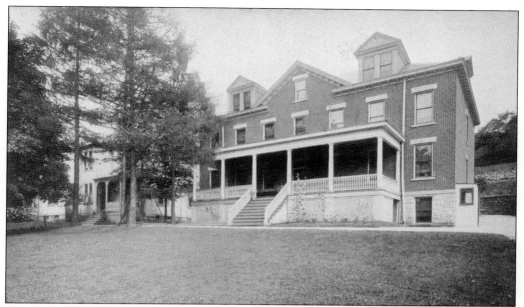

Fair Oaks founded one of the first retirement communities in Pittsburgh. In the beginning it served the German-speaking community associated with the Congregationalist Church of Smithfield Street downtown. The original building in Fair Oaks, Pennsylvania, can be seen here and was the summer estate of J. M. Stoner. Later the institution was moved to West Liberty where it still exists today.

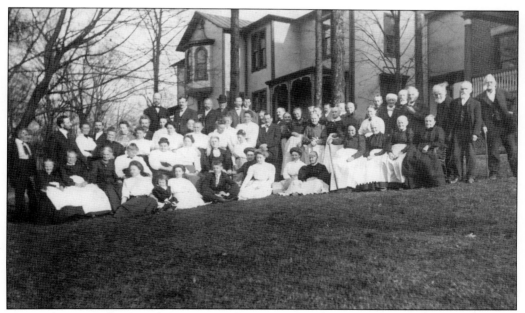

Here is the original group of German-speaking retirees at the Fair Oaks *Altenheim*, or home for the aged. This photograph dates back to 1891, when the first German home for the aged was founded in connection with the German Evangelical Protestant Church.

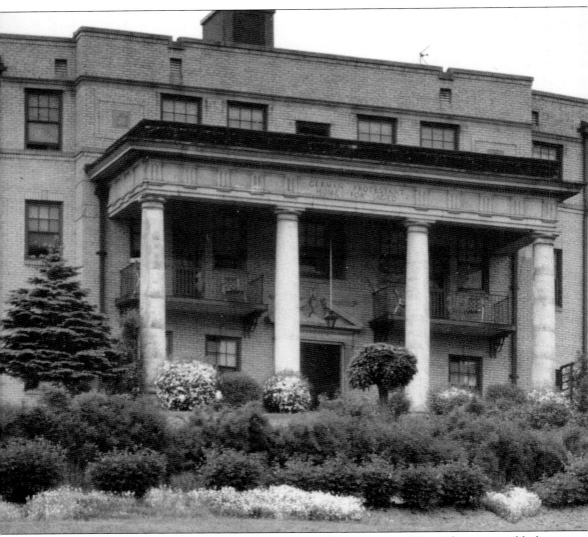

The newer building of the Fair Oaks Retirement Community in West Liberty is visible here. Subsequently a more modern structure was constructed in a high-rise fashion that stands today. This photograph is dated 1961. The inscription "German Protestant Home for Aged" is visible here, but it is obscured today on the building.

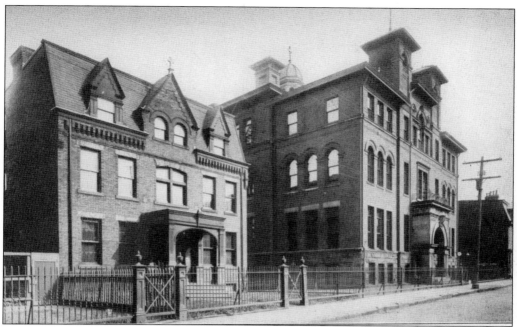

St. Joseph's Roman Catholic German School was located at the corner of Clay and Eighth Streets in Sharpsburg.

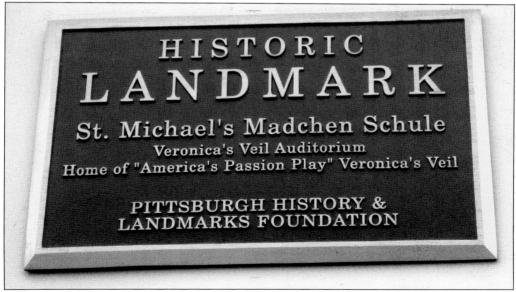

On many buildings in Pittsburgh in German neighborhoods, historic building markers can be seen bearing witness to the German American history of the building. Here is the old German girls' school (*Mädchen Schule*) on the South Side slopes, also home to the passion play.

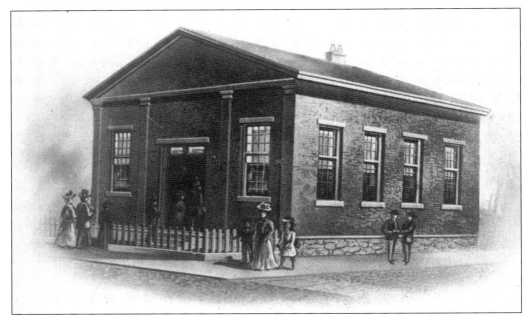

Here is the first schoolhouse of the First German Evangelical Lutheran Church. This one-room schoolhouse was used to instruct children in the German language.

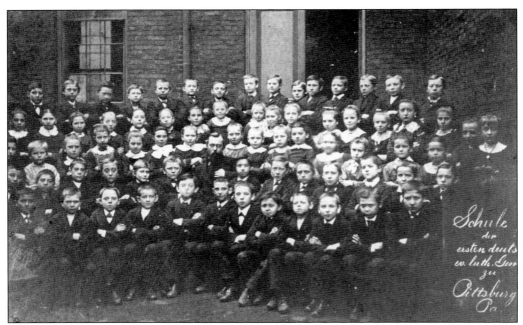

It was very common for religious organizations of the 19th and early 20th centuries to also have religious schools associated with them. In the case of the German religious organizations, the language of instruction was clearly German. Here is a class picture from the First German Evangelical Lutheran Church.

Institutions come in the form of traditions as well. The *Gendenksgottesdienst*, or memorial service, is celebrated each year in the beginning of November on Troy Hill at St. Anthony's chapel. It commemorates the deceased members of the German American community, and local choirs participate by singing in German.

G.T.E.V. D'Lustigen Isartaler Bavarian Club

Gedenkgottesdienst

Sonntag, den 13. November 2005
Sankt Antonius Kapelle
Troy Hill, Pittsburgh, Pennsylvania

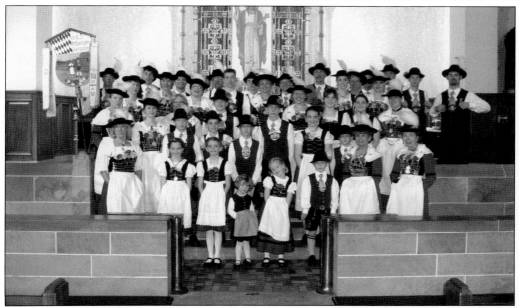

D'Lustigen Isartaler is a traditional German dance group active in the Pittsburgh community. Members take part in numerous German-related events throughout the year involving traditional dance and costumes (or *Tracht*), and pledge in their motto to stay true to old customs, *Treu dem guten alten Brauch*. They were formed in 1972 and now have members from around the Pittsburgh area.

Religion was the cornerstone of life for many German speakers in Pittsburgh. As one travels through the city, one can see old churches and cemeteries that bear witness to the past. Here is the entrance to the Smithfield Cemetery on Forbes Avenue in Oakland. Many inscriptions on the headstones are still in German.

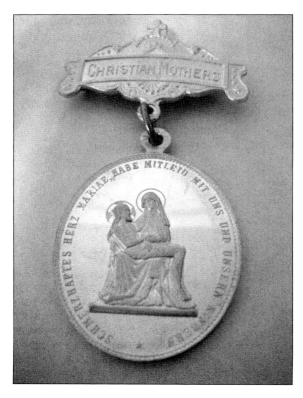

Here is a Catholic medal for the German Christian Mothers' Association. The medal states, translated from German, "Maria, have mercy on us and our children."

The Knights of St. George was a Catholic beneficial society founded in Pittsburgh. The society was founded by and for German-speaking Catholics in the area.

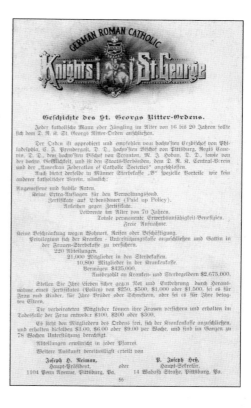

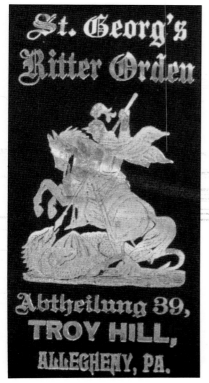

Here is a German Knights of St. George medal that was worn by members. The chapter is from Troy Hill in Allegheny, today the North Side.

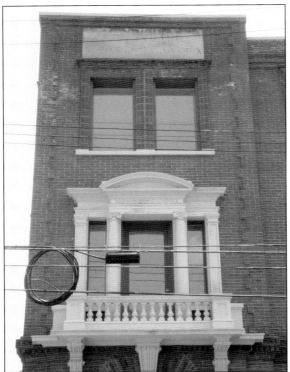

The inscription on this South Side building reads *Schiller Glocke Turn und Gesang Verein*. The organization is a combination of many types of German organizations. The Schiller Glocke refers to the classic German author Friedrich Schiller. One of his most famous poems was "Das Lied von der Glocke" (the Song of the Bell). Additionally, the organization was both a Turner (athletic) and Gesang Verein (singing society).

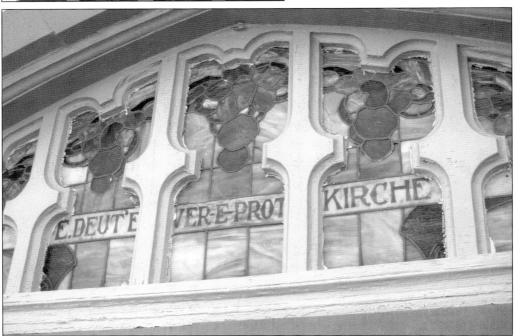

Here is one of many inscriptions of former German churches in the area. This inscription is almost obscured by the woodwork on the stained glass, but shows the roots of the church. The church is still in use as the Mount Washington Congregational Church.

Five

SOCIAL LIFE

Here is a section from *All Sorts of Pittsburgers* by A. G. Burgoyne:

> Though the South Side he owns as his birthplace, his name
> Is Dutch, and to German decent he lays claim,
> And hence he's resorted
> To beer that's imported,
> For Deutschland his love to display,
> And draws from the cask in a fashion Teutonic
> The lager that ripples like music harmonic
> Till Johann and Ernest
> Are tempted the derndest
> To enter that North Side Café.

Social life for German Pittsburghers was mostly spent among other German speakers. The immigrants gathered together among others who spoke their language, understood their traditions, sang their songs, and in many cases enjoyed lager beer and Rhine wines.

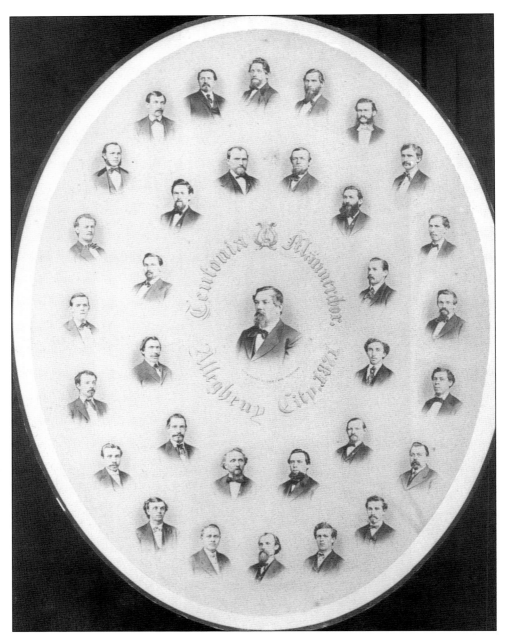

The Teutonia Männerchor is one of the oldest singing societies in Pittsburgh and is today the largest German American society in the city. Dedicated to the promotion of German choral song, it was founded in 1854 and practiced and met at various locations on the North Side until the purchase of land and buildings on what now is known as Phineas Street. On April 9, 1887, it were granted a charter by the commonwealth and was incorporated. Here is the oldest membership photograph dating back to 1871. Secular societies provided an outlet for social, political, and cultural heritage in the New World. German speakers of various faiths would gather in their *Verein* or club to discuss the issues of the day or to enjoy good company and to hear the language and music that they knew best.

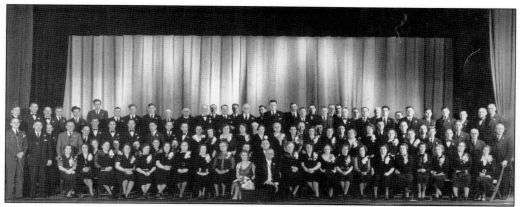

The Teutonia Männerchor has a long history of giving concerts in Pittsburgh to celebrate German culture through song. Here is a choir group in the 1930s. Its charter states that the "purposes of this Society shall be to further choral singing, our German cultural tradition and good fellowship." Regular concerts are still given to this day.

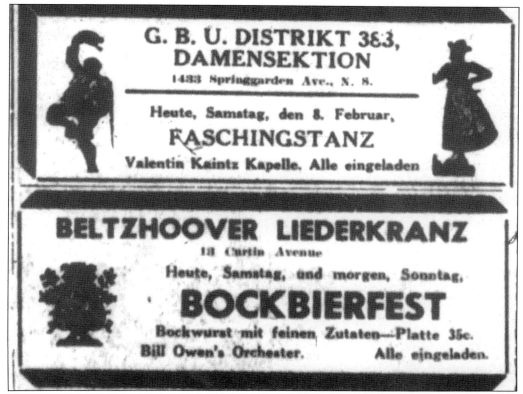

Many social events were advertised in the local German newspaper *Freiheits Freund*, or Freedom's Friend. Seen here is an advertisement for local events sponsored by various German-speaking organizations in Pittsburgh such as the Bock Beer festival and a ladies dancing evening.

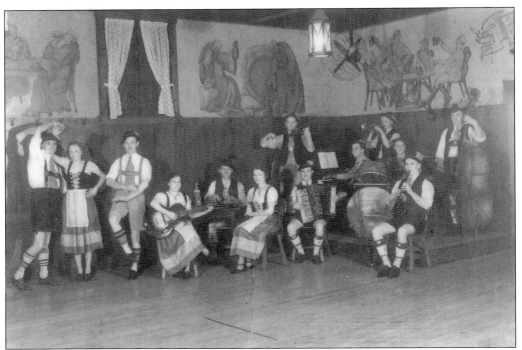

The Teutonia Männerchor has been celebrating its ethnic heritage through song and dance for over 150 years. Here is an older photograph from the *Rathskeller,* or basement, of its hall on the North Side. One can see the traditional (Bavarian) dress of the members and the band playing what was probably traditional German music. Such events still happen today on a regular basis at the Männerchor Hall, now on the National Register of Historic Places.

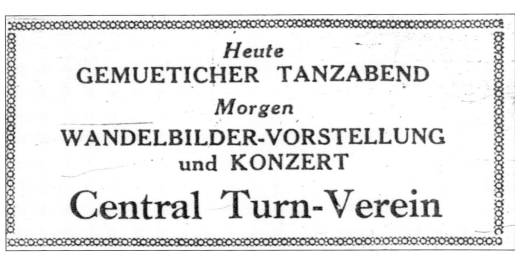

Heute
GEMUETICHER TANZABEND
Morgen
WANDELBILDER-VORSTELLUNG
und KONZERT
Central Turn-Verein

This advertisement from the Central Turner Society on the North Side advertises a concert and dance evening. Dancing, dinners, picnics, and nights of classical music were common among the various German-language societies of Pittsburgh.

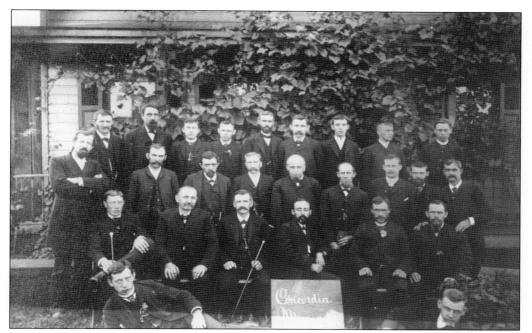

Singing is a favorite pastime of German speakers and a great way to practice using the language. Not only secular organizations had specific choirs. Here is the *Männerchor* (men's choir) of the First German Lutheran Church.

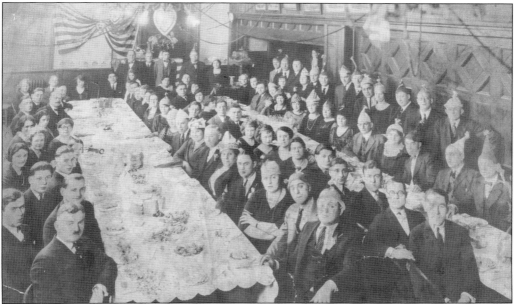

Social life revolved in many ways around the secular and nonsecular societies of the German-speaking neighborhoods. Many events were held specifically for the German-speaking immigrants. The halls of these societies were used for official meetings and social gatherings. Here is a birthday party held in the South Side *Turnverein* or athletics society on Jane Street.

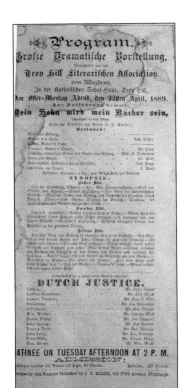

German-speaking immigrants also promoted their culture through theatrical performances. This playbill highlights a theatrical performance on Troy Hill called "Your son will be my avenger!" The synopsis and description are provided in German. In conclusion a comedy called "Dutch Justice" is to be performed, a wordplay on the term "Dutch" for "Deutsch."

Seen here is an advertisement for a picnic organized by the German Austrian singing society. Picnics and trips out into nature were common among the German immigrants of Pittsburgh. The pollution of the city made outdoor activities next to impossible.

Deutsch=Oesterreicher Gesang und Musik=Verein,

Nordseite, Pittsburgh, Pa.

Sie, Familie und Freunde sind hiermit höflichst eingeladen zur Teilnahme an einem

Picnic

das am

Sonntag, den 19. August 1928 in Millers Grove, Stanton Ave., Millvale, abgehalten wird. Jedermann willkommen. Vergnügen für alle ist zugesichert. Nehmt Millvale Car, steigt aus an Howard und North Ave. Nur ein kurzer Weg. 8=12!

The celebration of spring on the first of May is a tradition in many European countries. The traditional May dance around a maypole is one that is a custom particularly beloved among the Germans. Here is an advertisement for a May dance held by the German Engineering Society of Pittsburgh.

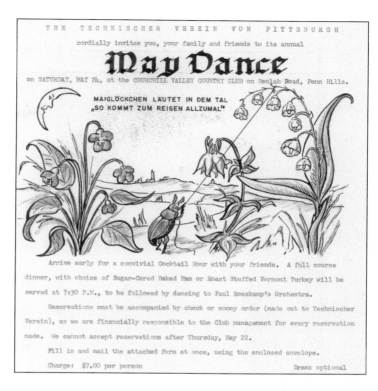

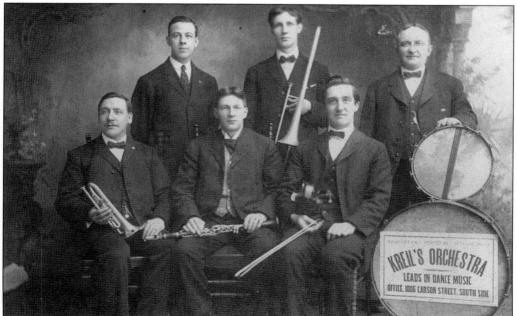

Music not only came from the singing societies. Many bands and orchestras with German-speaking members can be found in the history of the city. Here Kreils Orchestra played on the South Side, undoubtedly in one of the many lager beer halls found on Carson Street. They claim to be the "Leaders in Dance Music." Carson Street today is also know for its beer halls and music venues.

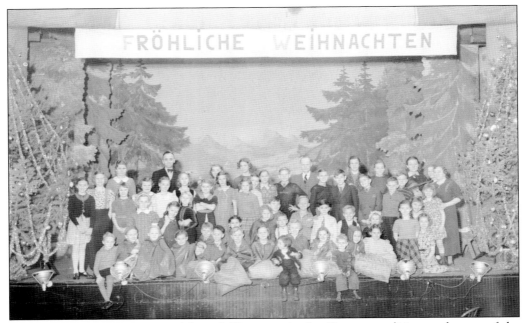

Many German organizations celebrated Christmas in the German tradition, and many of the German traditions and songs were adopted by Americans. Here is a children's group at the Teutonia Männerchor building on the North Side.

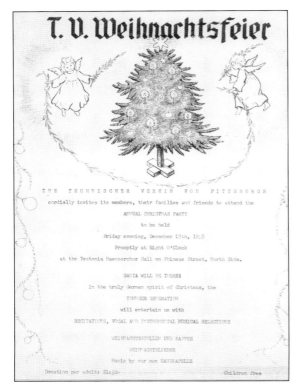

Even the German Engineering Society of Pittsburgh sought to carry on traditions from the Old World. Here is an advertisement for one of its Christmas festivals from 1958. The celebration includes traditional songs and music, a traditional cake (*Stollen*), and St. Nikolaus for the children.

Six

PLACES AND PEOPLE

This is a 1958 German-English mixed poem from the German American Engineering Society referencing Wiegands Café on the North Side, a popular spot for German speakers in Pittsburgh:

> It makes for never mind, but
> You get too soon old und too late schmart.
> Met so viel grexen its all so verhoodled
> dot you chust haff to forget your trubles
> und shoosel over onct to Wiegands on Dunnershdawg
> und eat yourself full.

German Pittsburghers speak in code sometimes. The places they reference, the people they know, and the words they use are very segregated from others. To overcome this, all one needs to do is step into a German neighborhood in the city and within a short period of time, one knows the people and places and might just learn some German.

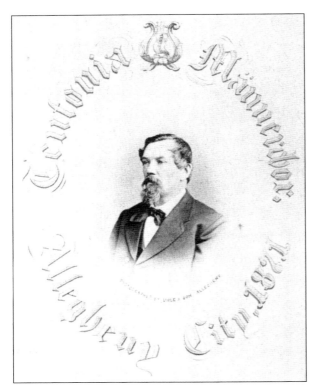

If one place had to be chosen for its German heritage, it would be Allegheny City, now known in Pittsburgh as the North Side. Its offshoots, industry, clubs, and events have shaped the history of the city, not just among German Americans.

If one person had to be chosen to represent German Americans, it would be the lifelong Troy Hill resident, historian, and local activist Mary Brueckner, known to many as Mary Wohleber. She claims to be a strong-willed woman who carries on many of the traditions of the Germans in everyday life. She keeps her "beer in the basement, washes her clothes by hand, and is feared by members of the city council." Her tireless work and encyclopedic knowledge of local history have caused many historians and city officials to make the trek up to her Troy Hill house seeking information, wisdom, and humor.

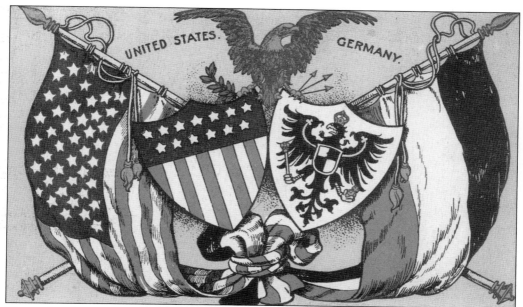

The nationalist tendencies in the German-speaking world led to the idea and political reality of the German nation state. Only after 1871 did Germany exist as a political entity. Even shortly thereafter this German concept was paired as a friend of the United States. Here is an image pairing both the flags of the United states and Germany during this period from 1871 to 1914. Despite the fact that many Germans still spoke in their language, many of the organizations had a strong pro-American slant. Clubs and organizations often touted the freedom-loving aspects of America, despite their connection to the old country.

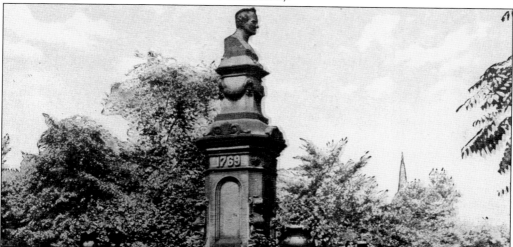

During this time of German nationalism, some of the great thinkers and writers from the German-speaking lands were highlighted in Germany and beyond. In West Park on the North Side, this monument to Alexander von Humboldt was erected. Humboldt was a German philosopher and intellectual founder of the German education system. The various Masonic orders of the city joined together to raise the funds and erect the monument to one of Germany's greatest intellectual thinkers. Shortly before World War II, the document was desecrated several times and eventually disappeared mysteriously from West Park, never to be found again.

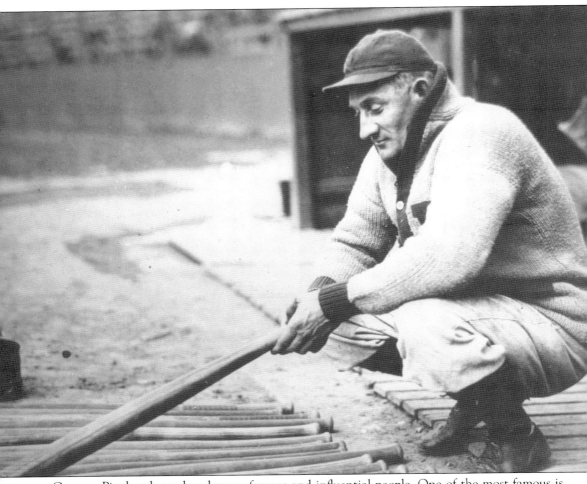

German Pittsburgh produced many famous and influential people. One of the most famous is Johannes Peter Wagner, known to Pirates fans as "Honus," a shortened version of Johannes, somewhat like the common nickname "Hans." His parents emigrated from the Rheinland area in Germany, and Honus grew up in a German-speaking home and attended a German religious school at St. John's Lutheran Church. He became the all-time leading scorer for the Pirates and is widely considered the greatest baseball player ever. (Courtesy of Pittsburgh Pirates.)

The Honus Wagner Memorial stands in front of the home plate entrance to PNC Park. The monument honors the German American Johannes Peter Wagner, also known as the "Flying Dutchman." The term comes from the frequent use of the term Dutch for Deutsch, or German.

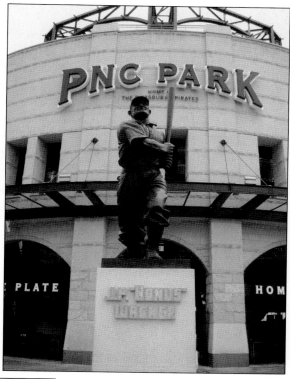

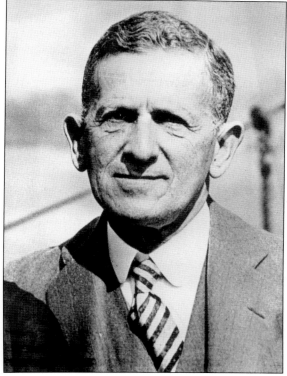

Another famous German-speaking Pittsburgher is the German-born Barney Dreyfuss. Dreyfuss acquired the Pittsburgh Pirates in 1899 and owned them until his death in 1932. He was responsible for bringing Honus Wagner and Fred Clarke to the team. He prompted the construction of the famous 25,000-seat Forbes field, deemed too large at the time but the opening day brought in over 30,000 visitors. Under his direction, the Pirates won six pennants and two World Series. (Courtesy of Pittsburgh Pirates.)

The Workingman's Beneficial Society of Pittsburgh in this advertisement sponsors several events including a wine tasting, dancing, and a photographic exhibit. It is not coincidental that German-speaking neighborhoods often are found on the rivers where the industrial centers were. Neighborhoods like Millvale, Braddock, and Homestead had sizable German American populations at one time.

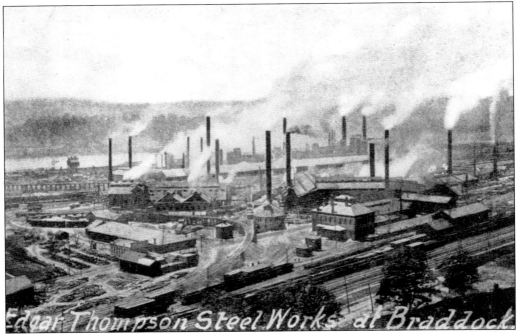

The steel mills of Braddock were one of many examples of the string of mills operating in the city. Braddock, like many communities near the river, had a sizable German-speaking community with churches, social clubs, and other organizations.

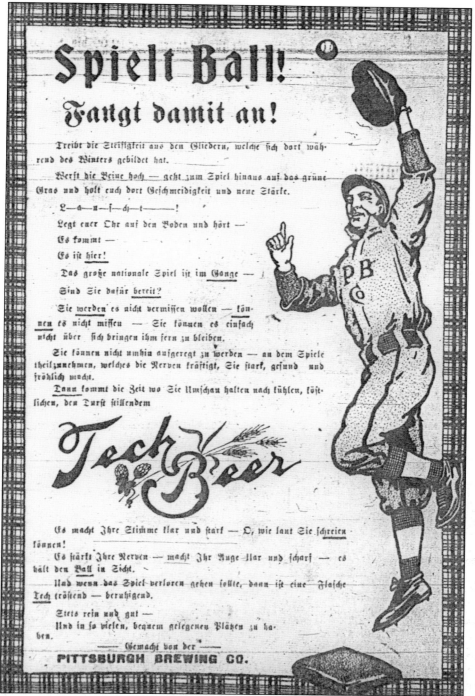

German Americans loved baseball. Not only because of Honus Wagner and other German-speaking players in the league, but for the simplicity of the game and the social aspects involved. This advertisement targets German-speaking baseball (and beer) lovers in Pittsburgh. The title literally translates "Play Ball!" into *Spielt Ball!*

Der Freiheits-Freund.

DAILY AND WEEKLY GERMAN NEWSPAPER.

545 Smithfield St., — PITTSBURG, PA.

THE OLDEST GERMAN NEWSPAPER WEST OF THE ALLEGHENY MOUNTAINS. CIRCU-LATION LARGER THAN THAT OF ALL THE OTHER GERMAN PAPERS OF THIS DISTRICT COMBINED. .·. .·. .·. .·.

THE

Freiheits-Freund

IS ACKNOWLEDGED BY ALL ADVERTISERS AS THE BEST MEDIUM TO REACH THE BEST CASH BUYERS, AND ITS COLUMNS PROVE THAT THE MERCHANTS OF THE TWIN CITIES TAKE ADVANTAGE OF THIS FACT. .·. .·. .·. .·.

—IT IS THE ONLY—

German Newspaper in Western Pennsylvania

+ + + THAT RECEIVES THE + + +

DAILY TELEGRAPHIC SERVICE ... OF THE ... "UNITED PRESS."	✷ WHILE ITS ✷	LOCAL NEWS COLUMNS ARE FRESH AND BRIGHT WITH ALL THE NEWS.

Der Freiheits Freund (Freedom's Friend) is the oldest German-language daily newspaper west of the Alleghenies. The newspaper printed an edition in German up through 1942. The newspaper was an official city newspaper for a time when a law required all city ordinances to be published in a daily German newspaper.

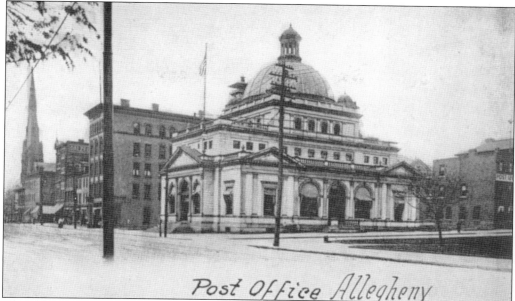

Post Office Allegheny

The old heart of Allegheny City, now the North Side, could be found on old Ohio Street. There were shops and stores of all kinds, a German newspaper, and a typical German market hall. Here is the old post office of Allegheny City, now the Children's Museum of Pittsburgh. This is one of the few buildings to survive the revitalization of the 1960s, which resulted in Allegheny Center.

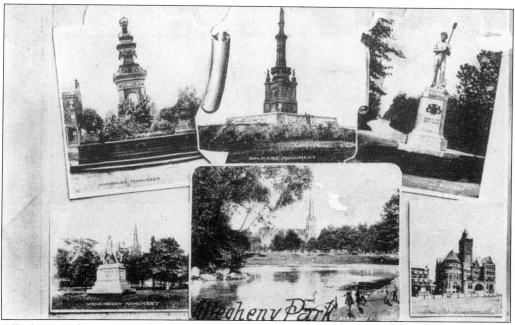

Allegheny Park

Allegheny Park, now West Park, was the park for German Americans on the North Side. Here the features of the park can be seen, including the Humboldt Monument, Soldiers Monument, and Washington Monument, as well as the lake found in the park.

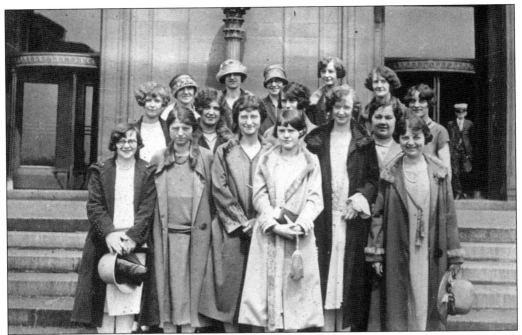

Here is a group of women from the First German Evangelical Lutheran Church of Pittsburgh on an outing to the city in the 1920s.

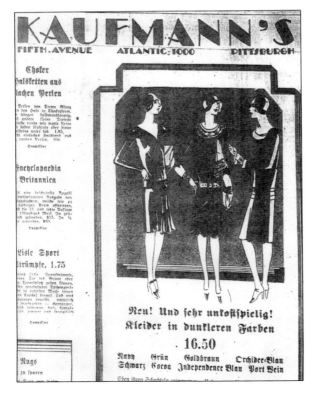

This advertisement from Kaufmann's department store from 1928 mirrors the fashions tastes of German American women in Pittsburgh. It markets the "new clothing in dark colors" such as gold-brown, independence blue, cocoa, and port wine.

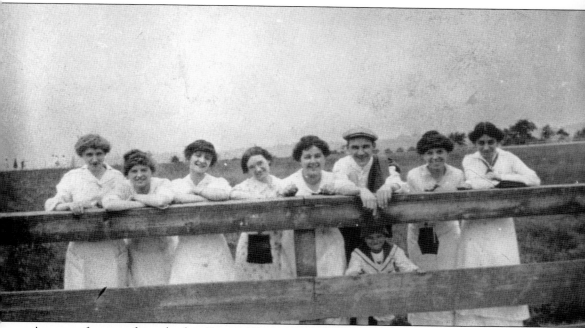

A group of women from the first German Evangelical Lutheran Church pose while on an outing in nature. The common anecdote from Pittsburgh states that residents would never wear white in the city, only dark clothes, because if they wore white outside in the city, they would be covered with soot from walking a block or so. Workers in stores downtown who were required to wear white would wear a different outfit just for the walk to work.

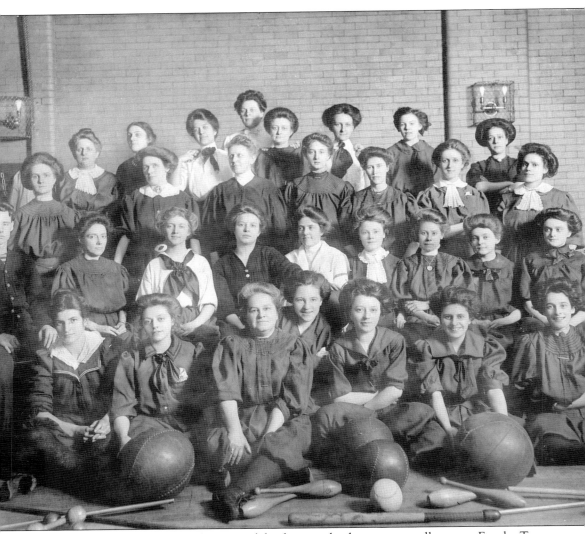

The institutions of German American life often involved women as well as men. For the Turner athletic societies, they were often segregated, but women were an active part of this athletic, social movement. This group of Turner women comes from Braddock, a mill town outside of Pittsburgh with a sizable German community. The Turner Hall was formerly located near the corner of Pine Way and Penn Street. (Courtesy of Bruce Evans.)

The old St. Mary's annex used to house a school for the church. It was saved and restored, and today houses a city hotel and banquet hall in the old church. The location is being revived as a social center.

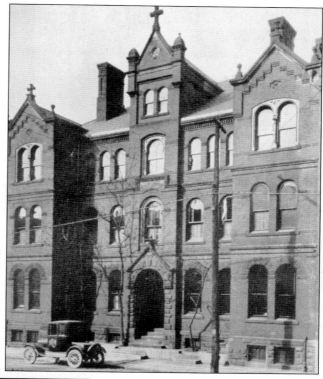

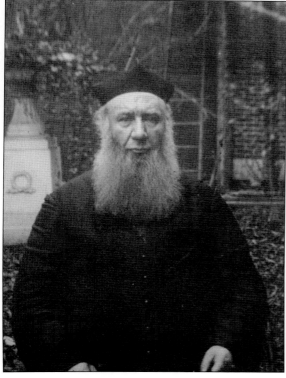

Father Mollinger was the first German-speaking priest in residence on Troy Hill. He was known as a healer and created several medicinal remedies for his parishioners. He is perhaps best known for his collection of reliquaries that currently reside in St. Anthony's chapel on Troy Hill. He collected the large amount of relics on his frequent trips back to Germany and Italy.

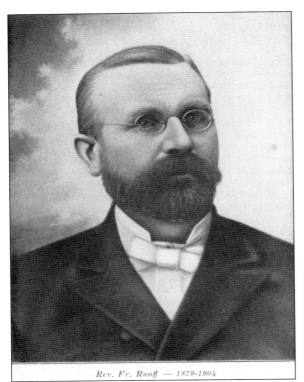

Rev. Fr. Ruoff — 1879-1904

Friedrich Ruoff, pastor at the Congregational church of Pittsburgh on Smithfield Street from 1879 to 1904, was also a founder of the German Protestant home for the aged. He felt that the church had a responsibility to care for its elder members.

Louis Naumberg and his daughter Carrie Cohen pose for this photograph. Dr. Naumberg was a German-speaking leader of the Rodef Shalom congregation and an important theologian in the United States for Reform Judaism.

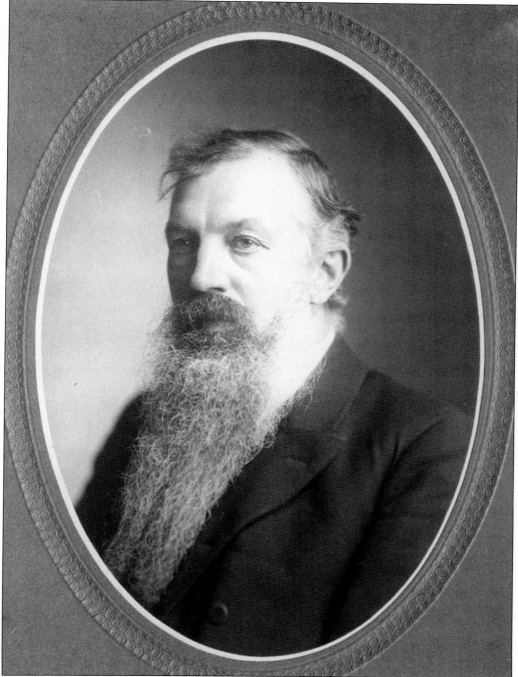

Pastor J. P. Beyer of the First German Evangelical Lutheran Church served from 1871 to 1880. He introduced the first children's paper for the congregation, the *Kinderblatt*.

Family life was central to the German-speaking community, and it was the family where most of the German was spoken. While there were several German-speaking schools in Pittsburgh, home life retained much of the values, language, and traditions. Here is a German American family on the front porch of their Troy Hill home. Since the father worked third shift, the mother became the leader of the family, common among many German American families of the area with men as industrial workers.

Tod. **Gericht.**

SIGN. CONF. ET ✝ COM. PASCHALIS,

Hl. Namen Jesu Kirche,

Troy Hill, Allegheny City, Pa.

1 8 9 7.

Kehre reuevoll zurück zu Gott.—Die Zeit der Gnade ist da

Name : *Annie Buechele.*

Distr.kt : ..

Himmel. **Hölle.**

German immigrants often associated themselves with other German speakers. This was true for both secular and nonsecular societies. Churches regularly held services in German, and entire congregations were founded solely on having a German-speaking pastor or priest. Here is the confessional card of a young girl from Troy Hill, with mostly words in German and the title in Latin.

The second-largest collection of reliquary antiquities is kept in St. Anthony's church on Troy Hill. This collection was a product of Father Mollinger, a German-educated pastor from what is today Belgium. Here is the annex, or Father Mollinger's residence.

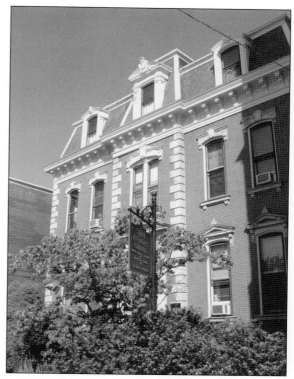

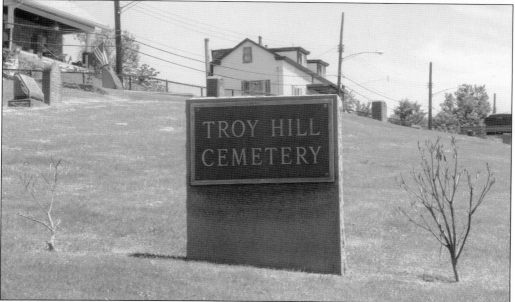

Many of the original Jewish immigrants to the Pittsburgh area came from German-speaking countries. When they came to the area, they continued to speak German and lived in the same German-speaking neighborhoods in the North Side and South Side. It was in these German-speaking neighborhoods that they built their houses of worship and buried their dead. The oldest of such cemeteries is on Troy Hill.

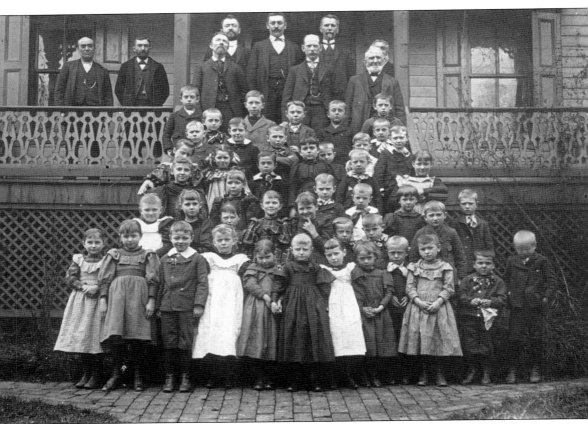

Here is a group of young schoolchildren in front of the pastor's home of the First German Evangelical Lutheran Church of Pittsburgh. Such school groups would likely have been held in German and English to help preserve the language of the members' cultural heritage.

Many photographs from the era are picture postcards featuring images of local Pittsburghers. This picture postcard features two children and the wish for a happy birthday.

The American citizens' league invites the German-speaking residents of the city to an event to open the winter season. Here they offer the chance to see how a radio show is made at their hall on Brighton Road.

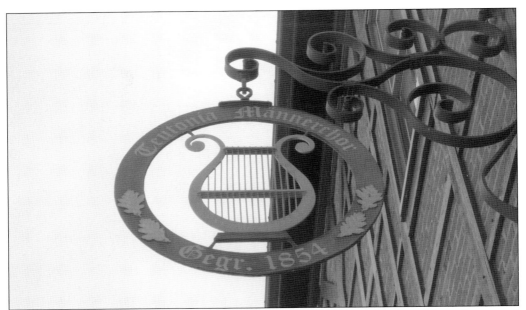

The lyre is the common symbol of many German-language singing societies. The oak tree and leaves are often used as symbols for German heritage as well. In this sign outside the Teutonia Hall on Phineas Street is both.

On many structures in the city one can still find German organizations representing themselves. Here is the common symbol of the German singing societies: the lyre. Singing societies served two purposes, first to provide a space for the German-speaking community to congregate and celebrate their heritage through German song, and second a space for social and political organization in the new world.

Seven

GERMAN PITTSBURGH TODAY

In Freud und Leid zum Lied bereit is the motto of the Teutonia Männerchor on the North Side. It translates to "in joy and sorrow prepared for song."

German Pittsburgh is experiencing a revitalization. Just as neighborhoods along the rivers are breathing new life, the people in these neighborhoods are feeling new pride for their city and its traditions. This quote fits well as it highlights the mindset of many Pittsburghers, even those who are not of German-speaking heritage. Even when things are bad, one can still be merry. This chapter explores the remnants and revitalization of German-speaking Pittsburgh.

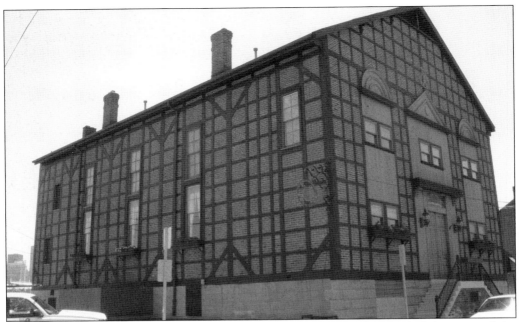

The Teutonia Männerchor's half-timber framed construction on the North Side is one of the best-known German-influenced structures in the city. The well-maintained structure is home to the largest German American organization in the city with over 2,200 members. It is a leader in the community and provides many events for its members and beyond.

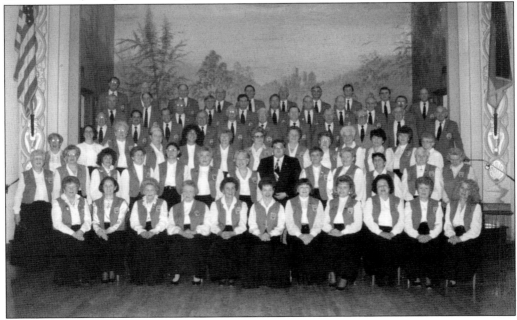

The Teutonia Männerchor of the North Side is still an active German singing society. Its mission is to promote German choral song. In 2004, it celebrated its 150th anniversary with a large celebration, bringing in letters of support and congratulations from around the globe. Here is a photograph of both the men's and women's choirs together.

The Priory Hotel is today an upscale city hotel in a European style. It was formerly a part of the St. Mary's Church complex. The church was to be torn down to make way for a new highway (279), but after protest, the project was moved 50 yards to save the building. The Graf family restored the church in 1986, and the hotel has 24 rooms.

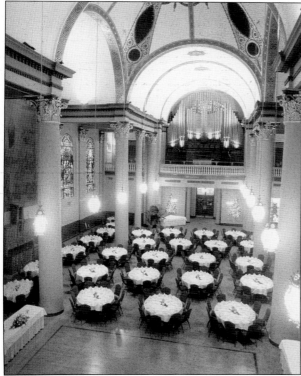

This is the interior of the former St. Mary's German Catholic Church, today one of the best places to get married and hold a reception in the city. Lovingly restored, the Grand Hall of Pittsburgh retains the historical nature of the building while promoting a new use.

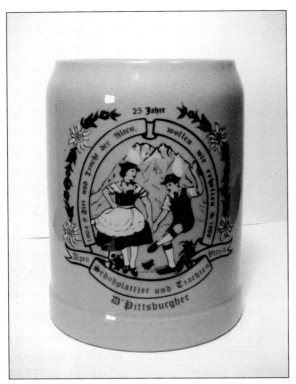

D-Lustigen Isartaler is a traditional dance group in Pittsburgh featuring traditional German dances from the Alpine region of Germany and Austria. Its children's group or *Kindergruppe* seeks to pass on the traditions to the next generation. It continues the tradition of commemorative mugs for the regional German American clubs.

The Turners promoted athletic activity for a sound mind and body. Many descendants of German Americans in Pittsburgh may have found these objects in their attics. These are so-called Indian pins, and were common exercise implements used by the Turner societies.

The area just north of the old Heinz plant on the North Side was affectionately known as *Deutschtown* due to the large number of German-speaking immigrants there. Today one can see this on the fire station on Spring Garden Avenue as well as on numerous signs in the area.

St. Michael's Catholic Parish on the South Side slopes served German-speaking members for many years not only with the church (now condominiums) but also with institutions of daily life. The inscription for the girls' school is still visible above the portal on Pius Street.

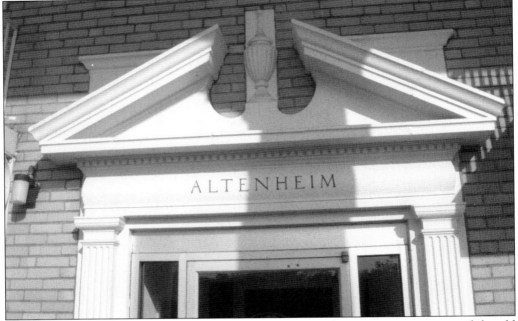

The Fair Oaks Retirement Community in West Liberty is the current incarnation of the old Protestant old folk's home. On the exterior of one of its older buildings, one still sees the old entrance marked *Altenheim*, or home for the aged.

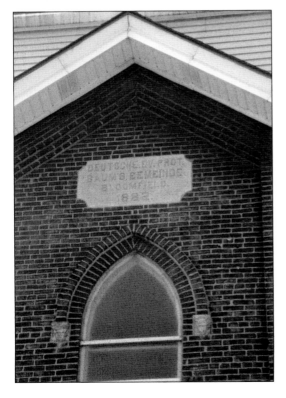

On many of the church facades in the city one will see a cornerstone piece or inscription above the windows stating the year of construction or purpose of the building. This church in Bloomfield has a German inscription showing construction in 1882.

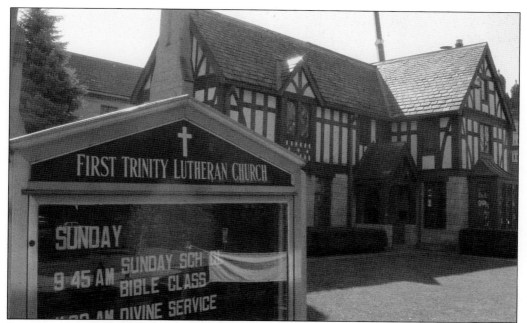

First Trinity Lutheran Church was the first Lutheran church in Pittsburgh and was originally German speaking. The church went through several incarnations and eventually constructed the current church in Oakland on Neville Street. Even today one can see the half-timber construction that is reminiscent of German-style architecture.

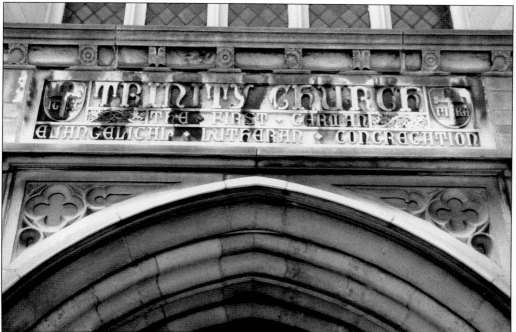

This is the inscription above the entrance to the current building of First Trinity Lutheran Church. Many buildings bear inscriptions marking their former language use. Here is the inscription in English, though denoting that it was formerly a German-speaking congregation.

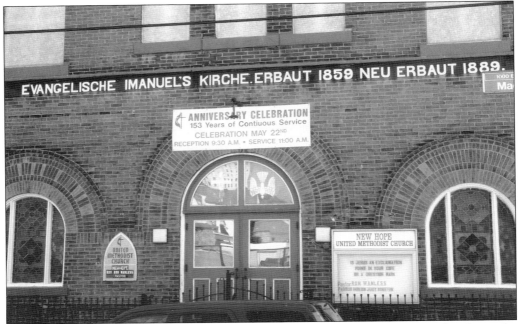

The New Hope Methodist Church's building still stands as a former German church on the North Side. The building marks the 153 years of service right below the old German inscription citing the two constructions of the church in 1859 and 1889.

The Bloomfield Liedertafel is a German singing society still in operation today. It occupies this building on Mathilda Street in Bloomfield. Bloomfield used to be a primarily German neighborhood, but is now considered the Little Italy of Pittsburgh.

Some former German buildings in Pittsburgh retain at least part of their character. This warehouse on the South Side used to be the bottling plant for Christian Moerlein Beer, a famous German American brew from Cincinnati. Today it is still used in an industrial capacity.

Currently called the Granite Building, the structure was originally built for the German National Bank of Pittsburgh. The advertisement of the old German bank is still visible on the side of the building to this day. It is located at the corner of Sixth and Wood Streets.

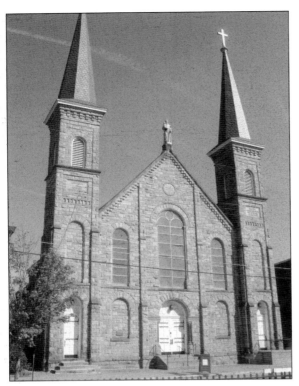

St. Anthony's on Troy Hill houses the second-largest collection of reliquaries in the world behind the Vatican. This world-famous collection was started by Father Mollinger of Troy Hill and can be viewed by simply showing up at the church during its regular hours.

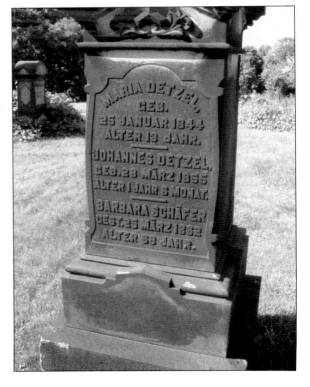

This monument is found in the German Evangelical Protestant Cemetery on Troy Hill. This cemetery has been repeatedly disturbed through expansions of Route 28. In the cemetery one can still find many headstones with German inscriptions and dedications.

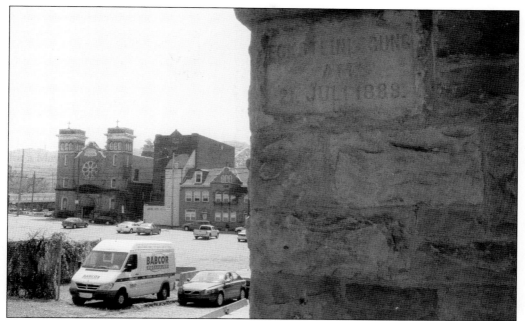

Many of the buildings housing German-speaking organizations, groups, and churches in Pittsburgh still bear the mark of the former institution. This building marks the construction date of the Central Turner Association of Pittsburgh. Today it is a warehouse across from the old Heinz plant.

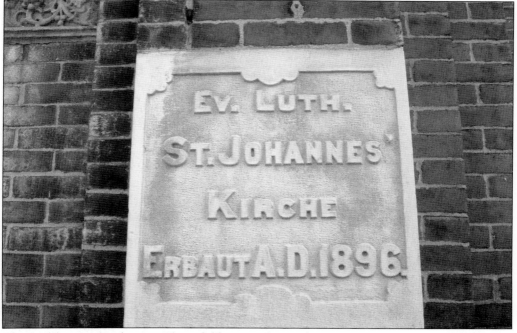

The St. Johannes Kirche near Bloomfield is one of many former German churches in the area to be converted to condominiums. The architectural features and redbrick facades of the buildings are attractive to this day.

The *Hofbräuhaus* is the world famous German beer hall and restaurant in Munich, Germany. It is not only a tourist destination, but a standard for beer halls around the world featuring traditional Bavarian food, Munich-style beer, Bavarian music, and large wooden tables at which customers sit together. In 2007, ground is set to break on the 17,000-square-foot facility in the formerly German neighborhood of Birmingham, now known as the South Side.

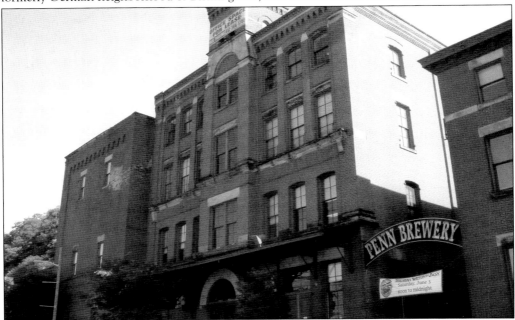

The Penn Brewery has become a Pittsburgh institution over the past 20 years. On the site of the former E&O brewery on the North Side, the Penn Brewery brews traditional German beers. It regularly has events themed around German holidays and festivals, and its beer can be purchased widely in the restaurants of the city and beyond.

Similarly, the German SDA (Seventh Day Adventist) church in Lawrenceville has its inscription above the door, albeit in English.

On many buildings on Pittsburgh one will see markings from formerly German-speaking organizations. While some are in the German language, others mark the organization. The BTV stands for the *Birmingham Turnverein*. Birmingham is now known as the South Side.

ACROSS AMERICA, PEOPLE ARE DISCOVERING SOMETHING WONDERFUL. *THEIR HERITAGE.*

Arcadia Publishing is the leading local history publisher in the United States. With more than 3,000 titles in print and hundreds of new titles released every year, Arcadia has extensive specialized experience chronicling the history of communities and celebrating America's hidden stories, bringing to life the people, places, and events from the past. To discover the history of other communities across the nation, please visit:

www.arcadiapublishing.com

Customized search tools allow you to find regional history books about the town where you grew up, the cities where your friends and family live, the town where your parents met, or even that retirement spot you've been dreaming about.